HENRY MOORE

A Shelter Sketchbook

HENRY MOORE

A Shelter Sketchbook

With a commentary by Frances Carey

PRESTEL-VERLAG

To Sir Denis Hamilton

The Trustees of the British Museum acknowledge with gratitude
the generosity of the Henry Moore Foundation for the grant which
made the publication of this book possible

Distribution for the USA and Canada only by te Neues Publishing
Company, 15 East 76 Street, New York, NY10021

Commentary © 1988 The Trustees of the British Museum
Introduction and drawings © The Henry Moore Foundation

Published by British Museum Publications Ltd
46 Bloomsbury Street, London WC1B 3QQ

Designed by James Shurmer

Originated and printed in the United Kingdom
by Westerham Press Ltd, Westerham, Kent

Printed in the United Kingdom

Prestel-Verlag, Munich ISBN 3–7913–0867–X

Contents

Introduction *in the words of Henry Moore* *page* 7

Commentary *Frances Carey* 14

Bibliography 21

The Sketchbook 23

Introduction *in the words of Henry Moore*

WHEN THE WAR broke out in September, 1939, I was teaching two days a week at Chelsea Art School and I had a studio at 11a Parkhill Road, Hampstead. But right from the start, when Irina and I were married in 1929, we always had a cottage in the country. At first it was at Dedham in Essex, then one of my sisters found us a cottage in the village of Barfreston in Kent, and in 1935 we bought a cottage with five acres of ground in a valley in Kingston, near Canterbury. The name of the cottage was 'Burcroft'. We spent all our summers there, and it gave me three or four months of uninterrupted carving every year. The reclining figure in green Hornton in the Tate and the big carving in elm wood which was eventually bought by Gordon Onslow-Ford were both done down there. The time spent at Burcroft was very valuable to me. It was there that I discovered that any piece of rough stone looked at home in the land-scape and realised that for me sculpture was an art of the open air. When war was declared I just went on working. The period of the 'phoney' war was very unsettling for many artists and I remember a younger sculptor friend telling me that suddenly he didn't know what he wanted to do, but for me it was a time for getting on with one's work.

There was a great invasion scare all over the southern counties when France fell in June 1940. They were putting up big poles in all the fields to prevent enemy aircraft landing, and the part of Kent in which we had our cottage – it was very near Dover – was declared a restricted area. Kenneth Clark invited us to go up to his place in Gloucestershire, Upton House, but we stayed on at the cottage because we were very fond of it and I was working well there.

Teaching at Chelsea School of Art was gradually coming to a standstill and a remnant of the students and staff was eventually evacuated to Northampton. But the

school was attached to the Chelsea Polytechnic and we were told that the Poly intended to start a course in precision tool-making to help the drive for munitions. By then, Kenneth Clark had been made chairman of the War Artists' Committee and invited me to become an official war artist. The Battle of Britain had started and Paul Nash was already painting aerial battles and the wreckage of enemy planes, but there didn't seem to me to be anything else to make the situation look strikingly different from the 'phoney' war period. So, along with Graham Sutherland, I volunteered instead for the course in tool-making. We were told that it would be started as quickly as possible and were asked to hold ourselves in readiness.

Irina and I left the cottage in Canterbury and went to our studio at 11a Parkhill Road. Ben Nicholson and Barbara Hepworth had two of the Mall studios off Parkhill Road, but they decided to evacuate to Cornwall because of the children and offered one of the studios to us. It was cheaper than our place so we accepted the offer and went to live at No. 7 The Mall Studios. Bernard Meadows had been helping me down at the cottage for about three months – he was my first assistant – and I recall that he helped us to put up the black-out curtains at No. 7. He was all for Stalin at the time, and we argued a great deal because I have never liked the idea of one man becoming all-powerful; but Bernard joined up when Germany attacked Russia.

Some of my sculpture was at Burcroft, but I had had a big show at the Leicester Galleries in January 1940 and the big elm piece and a lot of the lead sculpture was still in London, and I had them brought to the studio. I was expecting from day to day to hear from Chelsea Polytechnic and there was no point in starting work on a new sculpture when I might be called away at any moment, so I was doing nothing but drawings, and we were living on the proceeds of the Leicester Galleries show, .which amounted to something between four and five hundred pounds, quite a nice sum at that time. I had been told that the course would probably start in ten to fourteen days, but weeks went by and nothing happened. Germany had lost the Battle of Britain and there was a sort of uneasy lull. There were lots of air-raid warnings and some desultory

bombing of London and we went bathing in the pool on Hampstead Heath. When the blitz started I was still waiting to hear from the Polytechnic.

We owned a little Standard coupé and as a rule we used it when going into town. But one evening we arranged to meet some friends at a restaurant and for some reason or other went into town on the 24 bus instead of going by car. We returned home by Underground, taking the Northern Line train to Belsize Park station. It was a long time since I'd been down the tube. I'd noticed that long queues were forming outside Underground stations at about seven o'clock every evening but hadn't thought much about it, and now for the first time I saw people lying on the platforms at all the stations we passed: Leicester Square, Tottenham Court Road, Goodge Street, Euston, Camden Town, Chalk Farm. It happened to be the first night on which a big anti-aircraft barrage was put up all round London. I think it was done to help the morale of Londoners more than anything else: it made a terrific noise and gave the impression that we were hitting back at the raiders in a big way. When we got out at Belsize Park we were not allowed to leave the station because of the fierceness of the barrage. We stayed there for an hour and I was fascinated by the sight of people camping out deep under the ground. I had never seen so many rows of reclining figures and even the holes out of which the trains were coming seemed to me to be like the holes in my sculpture. And there were intimate little touches. Children fast asleep, with trains roaring past only a couple of yards away. People who were obviously strangers to one another forming tight little intimate groups. They were cut off from what was happening up above, but they were aware of it. There was tension in the air. They were a bit like the chorus in a Greek drama telling us about the violence we don't actually witness.

As I said, I had been compelled to concentrate on drawing, and it put me in the right mood to start drawing what I saw in the Underground. I purposely went by tube to various parts of London to see what differences there were between the stations. Some of the deepest shelters were not in the central area.

I never made any sketches in the Underground. It just wasn't possible. It would have

been like making sketches in the hold of a slave ship. One couldn't be as disinterested as that. Londoners had decided for themselves that the Underground was the safest place to be, and nothing was organised. There were no sanitary arrangements and no bunks. Some people brought their own mattresses, others simply lay on the concrete platform. Instead of drawing, I would wander casually past a group of people half a dozen times or so, pretending to be unaware of them. Sometimes I climbed the staircase so that I could write down a note on the back of an envelope without being seen. A note like 'two people sleeping under one blanket' would be enough of a reminder to enable me to make a sketch next day. Kenneth Clark saw some of these sketches and pointed out that I now had no excuse for refusing to be an official war artist.

I started a sketchbook, putting down ideas for drawings to be carried out later, sometimes adding the verbal notes made in the tube. The first sketchbook now belongs to Kenneth Clark. The one belonging to my wife was started immediately after the first was filled. I started one or two others, but a lot of the pages were torn out and used for other purposes and they are no longer in existence. I think there's a school exercise-book with a few scribbles in it somewhere in the house, but that's all. The two sketchbooks that survived are identical in format. They are cheap, tear-off pads with a cardboard back and originally contained a hundred sheets of thin paper quite suitable for jotting down ideas. They probably came from Bryce-Smith's artists' supply shop in Camden Town, where I bought most of my materials, and I seem to remember that they cost 1/6d each. They were bought before I had any intention of doing the shelter drawings.

The abstract painter Cecil Stephenson had the studio next to mine and, being a practical and efficient fellow, he built himself an air-raid shelter in the garden, and occasionally when the bombing was very bad we would join him there. One week-end a friend named Leonard Matters, who was a Labour MP, invited us out to his house at Much Hadham. We went down on the Friday in the Standard coupé and back Monday morning. When we got to the bottom of Haverstock Hill we found a rope across Parkhill Road, and the air-raid warden told us that Mall Studios was flat to the

ground. The rope was across the road because there was an unexploded bomb there, and we had to go round to the studios by the back way. We found that the warden had mistaken Parkhill Studios for Mall Studios, but although our place was not down it had suffered badly from the blast. The doors were blown out and all the windows and top lights smashed. Fortunately, only one of the sculptures was damaged – a reclining figure in brown Hornton. It's a rather soft stone and the figure was badly scratched by pieces of jagged glass. We managed to cover up the sculpture, but it was impossible to sleep there and we asked Leonard Matters if we could stay at his Much Hadham place until we found somewhere else to live.

At Much Hadham we heard that the owner of 'Hoglands' was away on some kind of war job and wanted to let half the house. His wife and three children occupied the other half. It was in a pretty tumble-down state, but anywhere was good enough in those days. On the first night we slept there the nose of an anti-aircraft shell came through the roof. A month or so later the owner's wife decided to go and live with her mother and offered to sell us Hoglands. This offer coincided with Gordon Onslow-Ford's offer of £300 for the big elm wood figure and this was exactly the amount of a one-third deposit on the house. We have lived at Hoglands ever since.

Being a war artist, I was entitled to a petrol allowance, and as Much Hadham is only thirty miles from the centre of London – at night we could see the red glow in the sky from the London fires – I was able to go to and fro in the Standard coupé. I went up to London for two days each week, spending the nights in the Underground, watching the people, and coming up at dawn. Then I would go back to Much Hadham and spend two days making sketches in the tear-off pad. The rest of the week I would be working on drawings to show to the War Artists' Committee. I showed them eight or ten at a time and they would take about half of them. I was allowed to do what I liked with the others.

I had a permit which got me into any Underground I wanted to visit. I had my favourites. Sometimes I went out to the station at Cricklewood, and I was very

interested in a huge shelter at Tilbury, which wasn't a tube station but the basement of *page 34*
a warehouse. But the shelter which interested me most of all was the Liverpool Street
Underground Extension. A new tunnel had been bored and the reinforcement of the *page 21*
walls completed, but there were no rails, and at night it was occupied along its entire
length by a double row of sleeping figures.

The sketches were done with pen and ink, wax crayons and watercolour. I used the
wax-resist technique, which I had discovered by accident some time before, when
trying to do a drawing for a three-year old niece of mine with the two or three stumps of
wax crayon which she provided. Her father is a schoolmaster and they lived at the
house adjoining the school, so he suggested that I could get some watercolours from one
of the class-rooms, and it was a sort of magic to see the watercolour run off the parts of
the drawing that had a surface of wax. I found it very useful when dashing down ideas
in the sketchbook to be able to let the watercolour run over areas that had already been
treated with crayon. I managed to get some of the white crayon that's used for marking
glass, and applied it to areas that I wanted to remain white. When the coating of wax is
too thin, the watercolour soaks through, and it will be seen that in a few of the sketches
small patches of watercolour have invaded areas of another colour.

It was strangely exciting to come out on to the street in the early hours of the morning
after a big raid, and I used to go down the back streets to see what damage had been
done. It was on one of these journeys that I saw a whole family – three generations of
them – sitting quietly together outside a blasted tenement building, waiting for some- *page 26*
thing to be done for them. And another time I saw an injured girl being brought out of a *page 64*
mass of debris with her hair all fluffed out by dust and plaster.

Bunks were not provided in the shelters until several months after the bombing
began; nor the canteens and decent sanitary arrangements. But from my point of view,
everything was then becoming too organised and commonplace. Up to perhaps the first
two months of 1941 there was the drama and the strangeness, and then for the people
themselves and for me it was all becoming routine. I mentioned to Herbert Read one

day that I didn't want to go on doing shelter drawings, and it was he who suggested that, with my background, coal-mining would be a good subject, being an industry of great national importance. I spent two weeks in a coal-mine, and was able to make sketches on the spot because the miners knew what I was there for. These sketches provided me with material for about three months of drawing, and when the drawings were completed I told Kenneth Clark that I would prefer not to take any more commissions. I started to work again on ideas for sculpture, and towards the end of 1942 I held an exhibition of fifty new drawings at Kurt Valentin's gallery in New York.

HENRY MOORE

Commentary *Frances Carey*

THIS BOOK reproduces in facsimile the first of the Shelter sketchbooks referred to in the preceding account by Henry Moore (1898–1986). It entered the Department of Prints and Drawings of the British Museum in 1977 as a bequest from Jane, Lady Clark, first wife of Moore's great patron and friend, Kenneth Clark. The second sketchbook, containing ninety-five pages of drawings, was made over to the Henry Moore Foundation by Irina Moore in 1977. The present publication is the only complete facsimile to have been produced of either of the two sketchbooks. The first attempt at a sequential publication of some of their pages was made in 1945 by Editions Poetry, London, who reproduced eighty-two sheets drawn from both sketchbooks. In 1967 the Ganymed Press in Berlin printed collotypes of eighty pages from the second sketchbook for Rembrandt Verlag; there was no attempt, however, to preserve either the format or the integrity of the original sketchbook, and the facsimile pages in no way correspond to the order of those in the sketchbook itself.

The Shelter sketchbooks, 1940–41, belong to a period of extraordinary fecundity in Moore's career as a draughtsman. From mid-1940 until the beginning of 1943 he concentrated exclusively on drawing, producing sheet after sheet of sculptural and more naturalistic figurative studies, often presented in pictorial settings and conceived on a monumental scale. The sketchbook studies formed the basis of approximately seventy-five larger drawings of varying sizes, to which Moore devoted an increasing amount of time once he had received an official commission from the War Artists' Advisory Committee on New Year's Day, 1941. On this occasion the WAAC purchased four of the large Shelter subjects for the sum of thirty-two guineas and during the course of 1941 it commissioned a further fourteen, the last of which was delivered on 24 September. These drawings were exhibited in the National Gallery

and provincial centres during the war years and then, in 1946, distributed to public collections, the Tate Gallery receiving the largest group.

From the beginning of 1941, Moore's work on the Shelter drawings was very much influenced by the public nature of his task, but originally they were conceived as a spontaneous response to the conditions created by the aerial bombardment of London, which extended from 9 September 1940 until 10 May 1941. The principal focus of Moore's interest was the Underground stations, where an average of 100,000 people sheltered each night during the Blitz: his first study of this subject appears on page 4 of the British Museum's sketchbook. However, as Moore himself points out, there were other situations whose visual possibilities attracted him: the Tilbury shelter, for example, in the East End of London, which was described by another contemporary observer as a 'vast, dim, cathedral-like structure' (Harrisson 1976, p.118), held a particular fascination for Moore, who first refers to it on page 34 of this sketchbook as 'A Large Public Shelter'. On page 45 his list headed 'War possible subjects' indicates the range of ideas suggested to him by the accidents of war, many of which appear on a miniature scale in a separate drawing from 1940, entitled *Eighteen Ideas for War Drawings* (Henry Moore Foundation).

The study of a little girl with plaits on page 9a demonstrates Moore's method of working up his compositions in the studio; in this case, his niece acted as a model to enable him to refine his mental recollection of a similar child from one of the Underground stations, who appears in a more perfunctory guise on pages 8 and 9, and again on page 24. (This drawing stands apart from the numbered sequence made by the artist because it was removed from the sketchbook shortly after its execution; it has now been reunited with the other pages for the purposes of this facsimile by kind permission of the owner.) By the middle of the sketchbook Moore has begun to develop certain themes more consistently, using frieze-like compositions where large groups of people are concerned, then increasing the scale to deal with one or two figures in isolation. Several of these more monumental figure studies from the second half of the sketchbook formed

the basis of larger Shelter compositions: pages 44 and 46, for example, were both squared up for possible enlargement, and used for drawings which entered the collections of the Tate Gallery, London, and the poet Stephen Spender respectively. In only one instance – page 33 – did Moore execute a drawing on the back of one of these pages; otherwise the versos simply bear the marks of the watercolour offsetting from the facing sketches. In this isolated case Moore was obviously intrigued by the accidental forms suggested by the offsetting, and decided to work them up with pen and ink into a proper composition.

On page 55 the artist has written: 'Do drawings worked out from some within notebook, but carried out more especially for sculpture.' The Shelter drawings were precipitated by direct observation from life, yet even the most naturalistic studies cannot be seen apart from Moore's preoccupations as a sculptor. Herbert Read, writing in *Art in Australia* in September 1941, stressed that in these drawings 'Henry Moore has surrendered nothing of his achievement, of his individual style, his "modernism". The whole meaning and substance of his past work is implicit in this new work' (p.13). Even the vivid use of colour, which is so remarkable a feature of the sketchbook pages in particular, was presaged in a series of studies of sculptural forms from 1937 onwards. The Shelter drawings played their role, too, in engineering Moore's return to sculpture. Canon Walter Hussey, then vicar of St Matthew's Church, Northampton, encountered Moore's work for the first time in 1942 when some of the large Shelter compositions were being exhibited at the National Gallery; he was sufficiently impressed by them – 'their dignity and three-dimensional quality seemed to make anything that was unfortunate enough to be hanging near them appear flat and dull' (W. Hussey, *Patron of Art*, London, 1985, p.23) – to offer Moore a commission for a monumental sculpture, the *Madonna and Child*, which was unveiled on 19 February 1944.

In a letter of 11 January 1943 to James Johnson Sweeney at the Museum of Modern Art, New York, Moore was dubious about whether the Shelter or Coal Mine drawings would exert any appreciable influence on his sculpture 'except for instance, in the

future, I may do sculpture which uses drapery, or perhaps do groups of two or three figures instead of only one figure' (Sweeney 1946, p.71). In a subsequent interview with Sweeney, however, upon the occasion of his first major retrospective at the Museum of Modern Art, December 1946 to March 1947, Moore acknowledges that the work for the *Madonna and Child* in Northampton and the later family groups (1944 onwards) did embody precisely those features which had first been fully explored in his Shelter subjects (see James 1966, p.218).

The Shelter drawings did not establish Moore's reputation as a major artist; that was already assured, and the publication in 1944 of a *catalogue raisonné* of his sculpture and drawings attested to his importance. The drawings did, however, both within Britain and through numerous exhibitions abroad from 1943 onwards, bring a far greater number of people into contact with his work than before the War. The Italian art historian Giulio Argan, later to become Mayor of Rome, was inspired by Poetry London's *Shelter Sketchbook* of 1945 to seek Moore out; in 1948 he wrote the first foreign monograph on him (published by De Silva, Turin; see Berthoud 1987, p.213). A former student at the Art Institute in Chicago has recalled the impact made by the retrospective exhibition which reached that city from New York in April 1947 and which included both Shelter sketchbooks as well as some of the larger drawings: 'The exhibition was a feast – a strong fresh wind blowing across the Atlantic. I remember the Shelter drawings made a very strong impression – we lost no time in trying to acquire the techniques of Moore's drawings and there was a rush for wax crayons and indian inks' (Berthoud 1987, p.207).

Moore was not the only artist to take an interest in the plight of Londoners sheltering from the Blitz. The distinguished photographer Bill Brandt was commissioned by the Ministry of Information to record conditions in London air-raid shelters at the same time. His keenly observed images were among a large body of photographs delivered to President Roosevelt in 1941 with the clear intention of influencing American foreign policy in favour of intervention against Germany. (A number of Brandt's most im-

pressive shelter subjects were published in *Lilliput* in December 1942 alongside Moore's drawings, with explanatory captions.) Prior to Moore's own commission the WAAC had already invited the illustrator Edward Ardizzone to work on the same subject, which he proceeded to do in a series of sprightly anecdotal drawings now to be found in the Imperial War Museum. Moore's interpretation was by comparison austere and static, somewhat removed from the average shelterer's own experience: '. . . His feature-less sleepers are all doomed and haunted . . . To him it is the collective pattern and not the individual experience that is of importance' (contemporary comment quoted by Eric Newton, 1945, p.9). There is no question that despite the acclaim the Shelter drawings immediately won in artistic circles, they remained curiously inaccessible to many of the ordinary people who saw them hanging in the National Gallery. Keith Vaughan, the anonymous reviewer for *Penguin New Writing* of the display of war artists' pictures at the National Gallery early in 1943, expressed more clearly than any other writer the problems presented by Henry Moore's work:

The decision to give Henry Moore, a sculptor with an exceedingly personal sense of form the material of tube shelters, the most widely familiar of war-time experiences was surely one of great foresight and courage, qualities which are so much a feature of this exhibition and for which we can only express gratitude to Sir Kenneth Clark and others responsible. Artistically it was fully justified. It is a tragedy, nevertheless understandable, that so many Londoners confronted with these drawings feel baffled and insulted. Here is a whole new underground world from which they feel themselves totally excluded, though the elements were all so familiar. The difficulty of course lies in Moore's conception of the human form, and some familiarity with his sculpture is essential I think to a full understanding of these drawings. The forms he has evolved for the presentation of the human figure have grown out of, and are intimately involved in, his materials of wood and stone. They can only be understood in relation to the organic structure of these materials. They are not forms devised in terms of a draughtsman's equipment from a contemplation of living people, but are essentially translated into this medium from a sculptor's conception in terms of wood and stone. It is useless here to look for the familiar or the apparent,

or even for any variation on these aspects. The value of these forms applied to this particular subject is that infused as they are with the feeling of growth and slow organic development in Moore's sculpture, they express so forcibly a sense of patience and timelessness. These motionless swathed figures belong to no accidental setting of time and place. Rather are they memorials to the enduringness of things, of stone and human patience and courage. The same fungoid phosphorescent texture covers skin, drapery, and the walls of the tunnels. Tunnels that suggest perhaps a fourth dimension of time.

I have heard people call these drawings morbid and unreal. I do not think either criticism is justified. The qualities they stress are not less real because they lie deeper than the obvious and the apparent. Beside their more sculptural quality there is much that is quite simply human. Look at the two figures in *Green and Red Sleepers* how a lifting fold of drapery lies like a caress across their shoulders, linking them together. The delicate and detailed modelling of lips and nostrils in the upturned faces seems to suggest the close-up minuteness and vividness of things in a dream, a troubled uncertain sleep; the smooth rounded contours broken into suddenly by the rake-like fingers of a hand clutching the blanket. Look closely at the face of the little boy in the foreground of *Rows of Sleepers*. He sits in his mother's loosely enfolding arms gazing outwards with open curious eyes at the spectators, the only one of Moore's figures which seem to acknowledge the existence of a world outside its own, and one of the subtlest and most beautiful passages of drawing in all these groups.

I think these drawings are very moving because Moore has not withheld himself from the full impact of this strange and tragic situation, but going beyond the apparent, has tried to discover and express those human and enduring qualities which would ultimately triumph and vindicate it. Moore made no studies for these drawings on the spot. To have done so, he said, would have appeared to be intruding on the sufferings of the people.

If Moore weighs the scales almost wholly in one direction, Ardizzone redresses the balance. Enter an Ardizzone shelter and you are in the thick of the steaming human throng. Here is the familiar moment, the bustling crowds, the burdened mothers with their endlessly tiresome children. The friendly voices, the smells, the chips in the newpaper, the easy-going cheerful society which was certainly part of shelter life. Ardizzone plays always on the sentimental, the vulgar and boisterous gaiety of the scene. . . . With Moore and Ardizzone you have perhaps the two extremes to which a war artist's vision can go, beyond lie the abstract and the surreal. (pp.112-14)

An independent film-maker, Jill Craigie, felt so strongly that the public did not understand the war pictures for which it was, indirectly, paying, that in 1944 she wrote and directed 'Out of Chaos', a thirty-minute documentary using the critic Eric Newton to provide some of the elucidation, while the artists themselves were asked to recreate the circumstances in which their work had been executed. Moore was filmed taking notes on the steps leading to an Underground platform covered in sleeping bodies, followed by a demonstration in his studio of how the Shelter drawings came to life through the combined effects of watercolour and wax crayon. The episode greatly impressed the camera crew but it is unlikely that the film dispelled the hostility of those who felt excluded from Moore's underground world. Moore himself was quite accustomed to his work being greeted with incredulity, and clearly stated his position as an artist in a radio discussion with V.S. Pritchett, Graham Sutherland and Kenneth Clark about 'Art and Life' in November 1941: '. . . for over twenty years I, like most artists, have been thinking all day long about sculpture and painting, and if after all that I only produced something which the average man, who has very little time to think about it, would immediately recognise as something he would have done if he'd had the technical experience, then I think that my time would not have been very profitably spent. I think that is true of the past too, and that all good art demands an effort from the observer, and he should demand that it extends his experience of life' (*The Listener*, 13 November 1941, p.658).

Bibliography

The bibliography on Henry Moore is so extensive that for the purposes of this publication a selection has been made of sources which are of particular relevance to the Shelter drawings. These are given in date order of publication.

Herbert Read, 'The drawings of Henry Moore', *Art in Australia*, series 4, no.3, 1 September 1941, pp.10–17.

Lilliput, December 1942, pp.473–82, reproduces some of the Shelter drawings alongside contemporary photographs by Bill Brandt.

Anon 'Art Critic', 'War Artists and the War', *The Penguin New Writing*, no.16, January –March 1943, pp.108–17.

Sheila Shannon, 'The Artist's Vision. A Shelter Picture of Henry Moore' (a poem), *The Spectator*, 23 June 1944, p.568.

Henry Moore, Sculpture and Drawings, with an introduction by Herbert Read, Lund Humphries, London, 1944 (2nd ed. 1946; 3rd ed. 1949; 4th ed. 1957).

Henry Moore, *Shelter Sketch Book*, Editions Poetry, London, 1945 (reproduces 82 pages drawn from the first and second Shelter sketchbooks).

Eric Newton, *War through Artists' Eyes*, John Murray, London, 1945.

A.D.B. Sylvester, 'Henry Moore. The Shelter Drawings', *Graphis* (Zurich), no.14, 1946, special number on 'England', pp.126–35, text in English, German and French.

James Johnson Sweeney, *Henry Moore*, exh. cat., Museum of Modern Art, New York, 1946.

Hans Theodor Flemming, *Henry Moore Katakomben*, Piper Verlag, Munich, 1956.

Constantine Fitzgibbon, *The Blitz*, Alan Wingate, London, 1957.

Philip James, ed., *Henry Moore on Sculpture*, Macdonald, London, 1966.

Henry Moore, *Shelter Sketch Book*, Marlborough Fine Art, London, and Rembrandt Verlag, Berlin, 1967 (facsimile of 80 out of 95 drawings in the second Shelter sketchbook).

Robert Melville and E. Petermann, *Die Shelterzeichnungen des Henry Moore*, exh. cat., Staatsgalerie Stuttgart, 1967.

Alan Wilkinson, introduction to *Henry Moore, Drawings, Gouaches, Watercolours*, exh. cat., Galerie Beyeler, Basle, 1970.

Kenneth Clark, *Henry Moore Drawings*, Thames & Hudson, London, 1974.

Joseph Darracott, *Henry Moore War Drawings*, exh. cat., Imperial War Museum, London, 1976.

Tom Harrisson, *Living through the Blitz*, Collins, London, 1976.

Alan Wilkinson, *The Drawings of Henry Moore*, exh. cat., Tate Gallery, London, in collaboration with the Art Gallery of Ontario, Toronto, 1978.

Henry Moore, *Shelter Sketch Book, mit Texten von Henry Moore, Will Grohmann, Robert Melville, Erwin Petermann, Klaus J. Lemmer*, Rembrandt Verlag, Berlin, 1981 (reduced-format edition, limited to 600 copies, of the 1967 facsimile).

Meirion and Susie Harries, *The War Artists*, Michael Joseph in association with the Imperial War Museum and the Tate Gallery, London, 1983.

Henry Moore, *Shelter and Coal Mining Drawings. Zeichnungen aus den Jahren 1939–42*. British Council travelling exhibition in East Germany, Nationalgalerie der Staatlichen Museen zu Berlin, 1984.

Roger Berthoud, *The Life of Henry Moore*, Faber and Faber, London, 1987.

A Shelter Sketchbook

Note The drawings have the British Museum registration numbers 1977-4-2-13 (1–67), with the exception of page 9a, which is in a private collection. Each page is numbered on the verso, in keeping with the artist's own numeration.

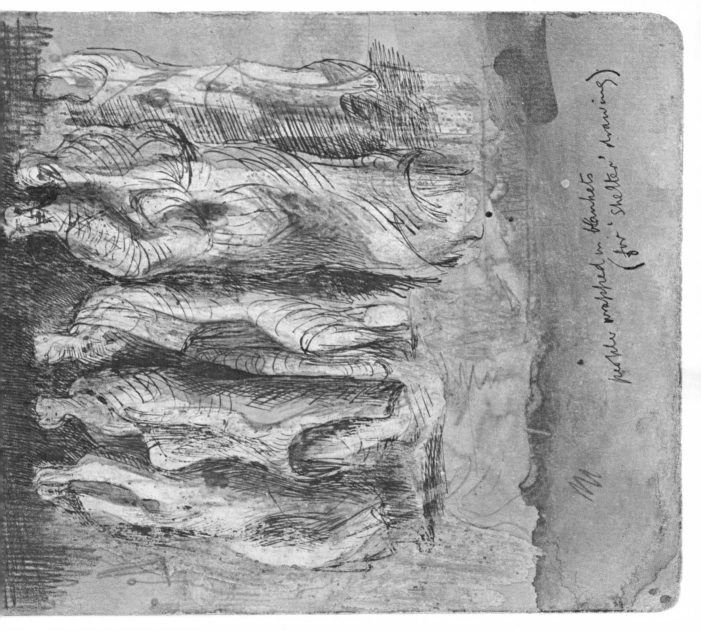

people wrapped in blankets
(for 'shelter' drawing)

1

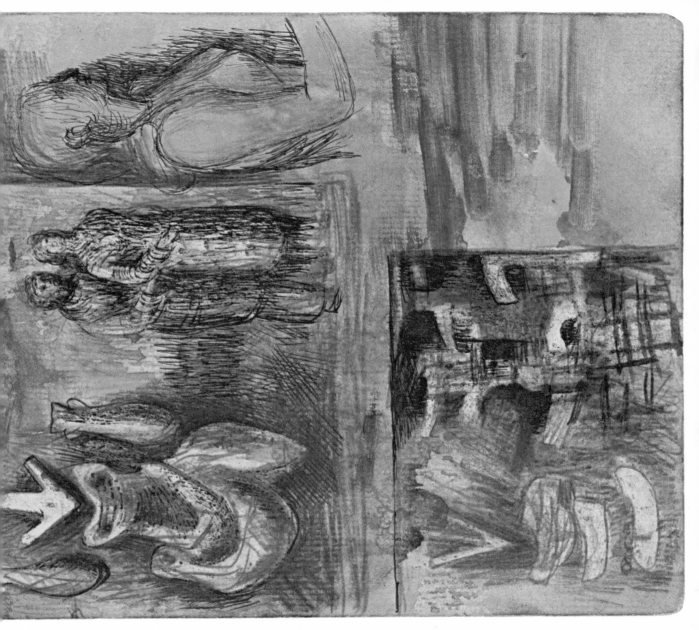

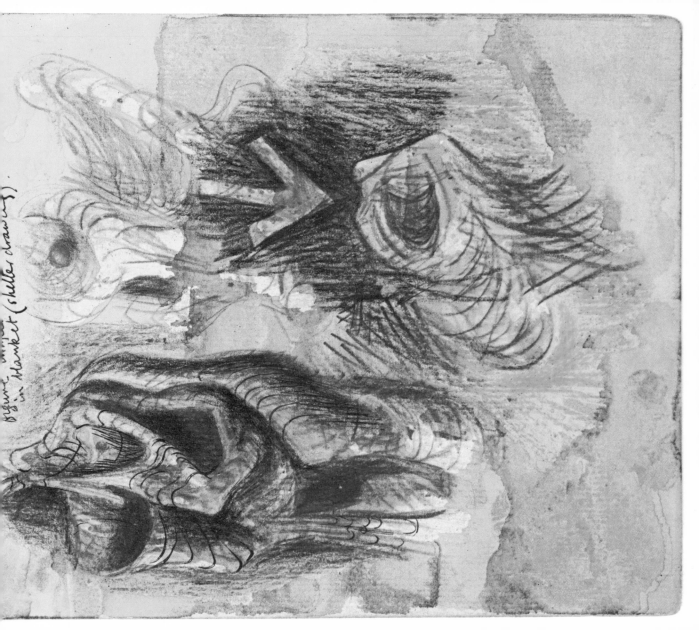

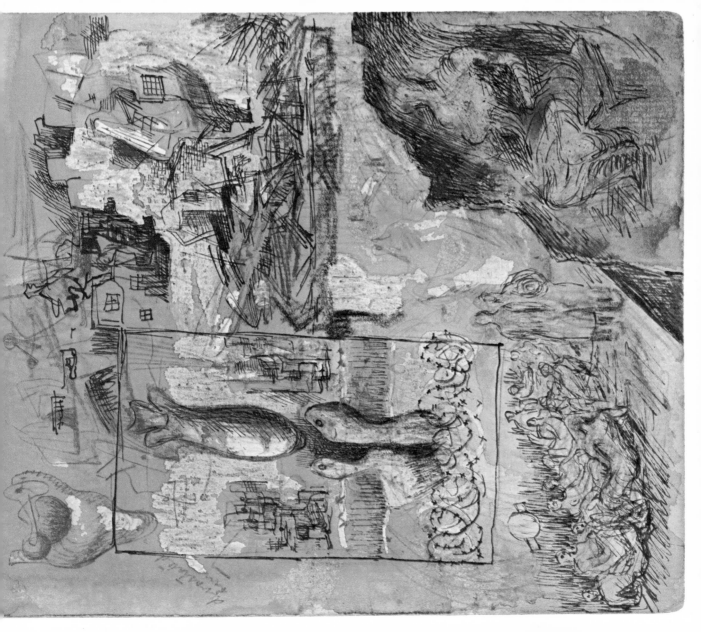

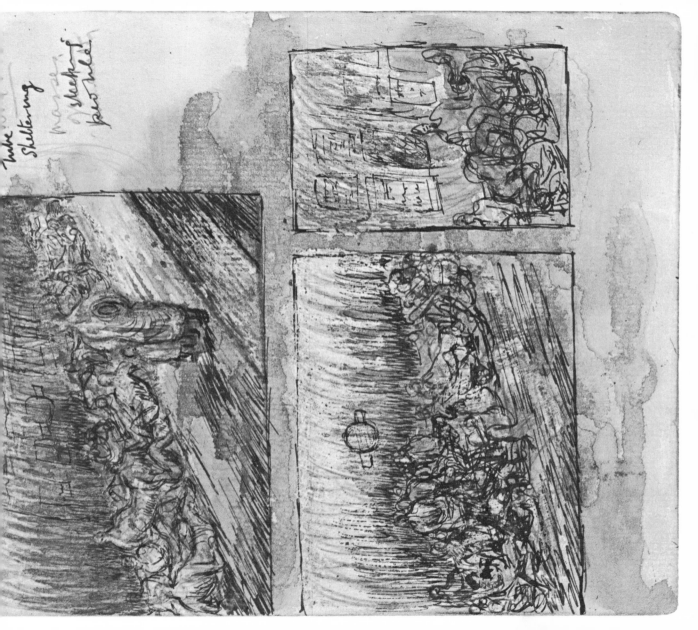

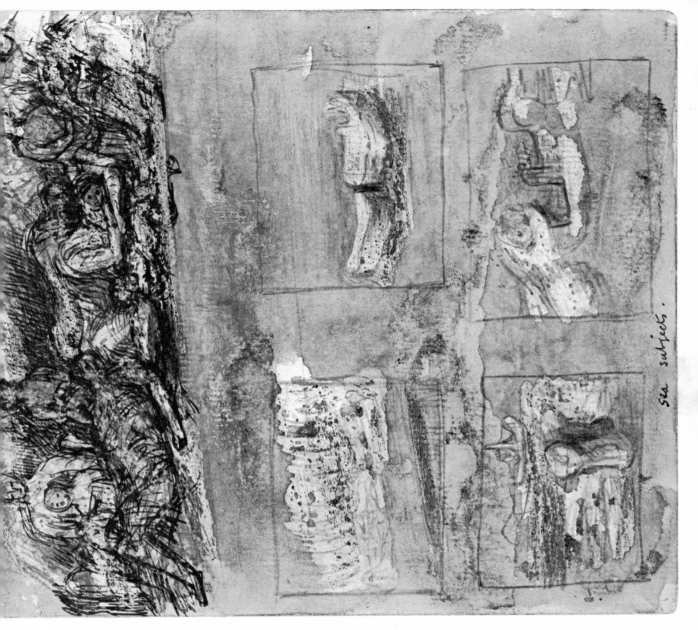

sea subjects.

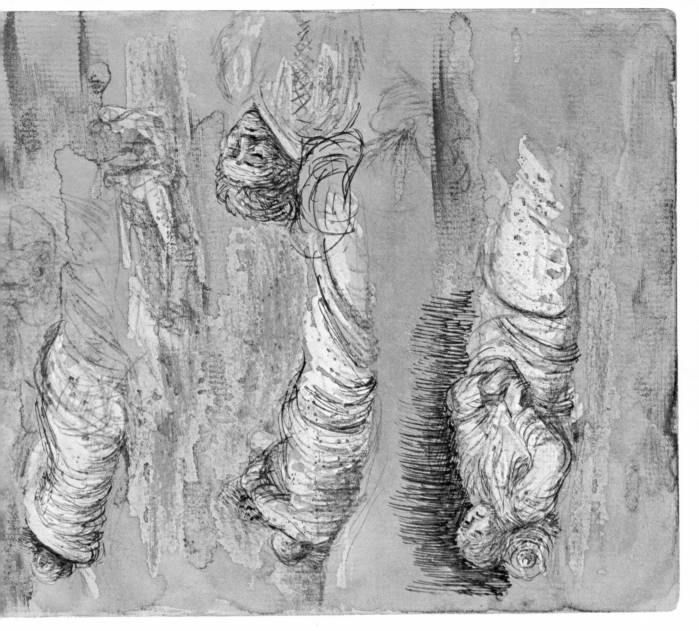

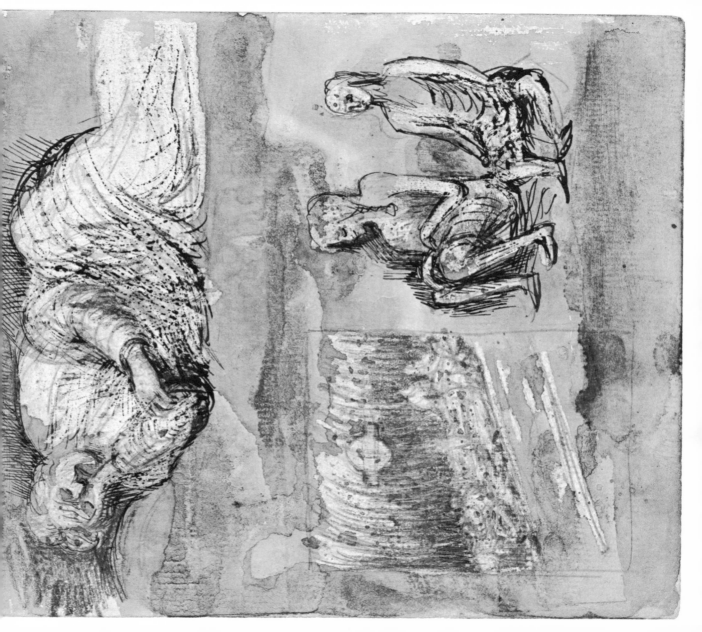

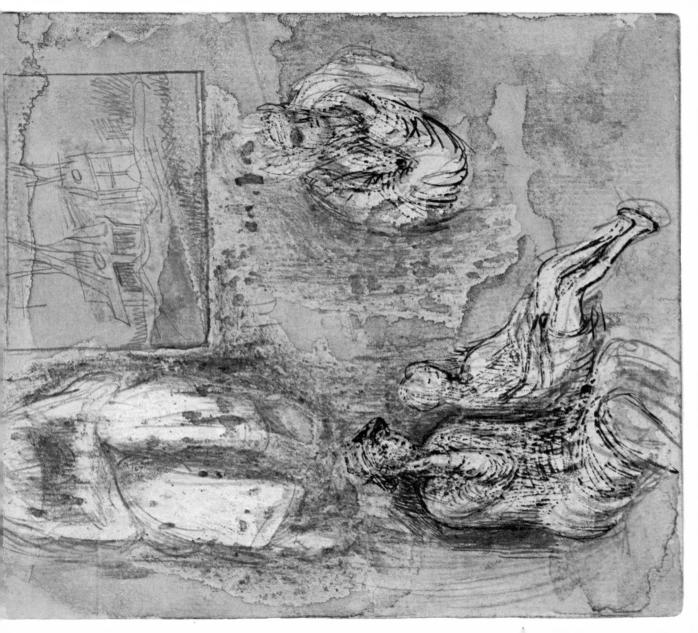

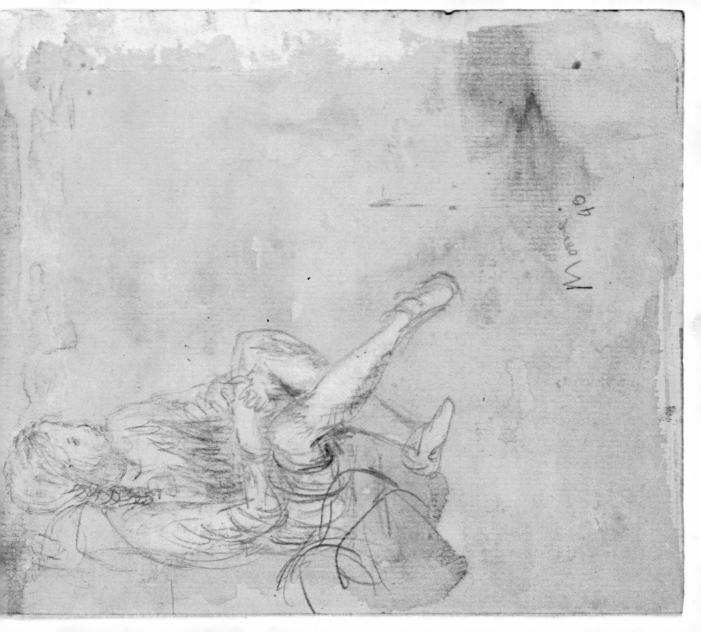

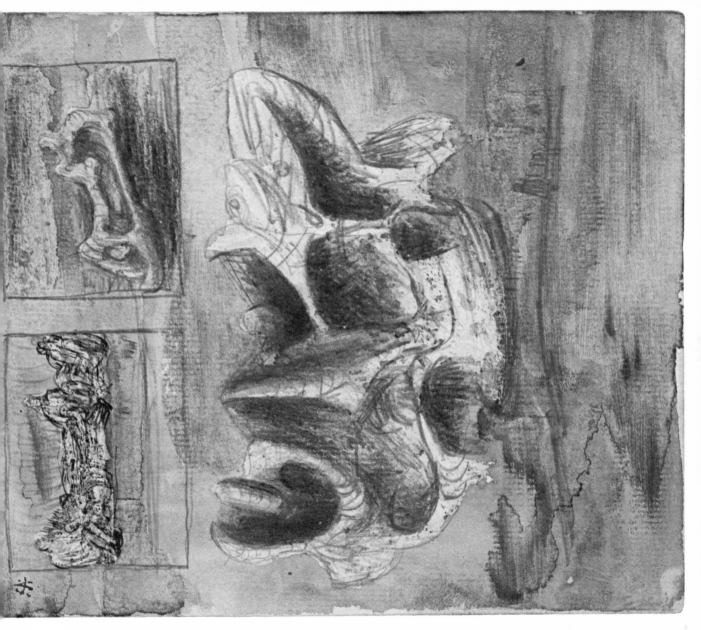

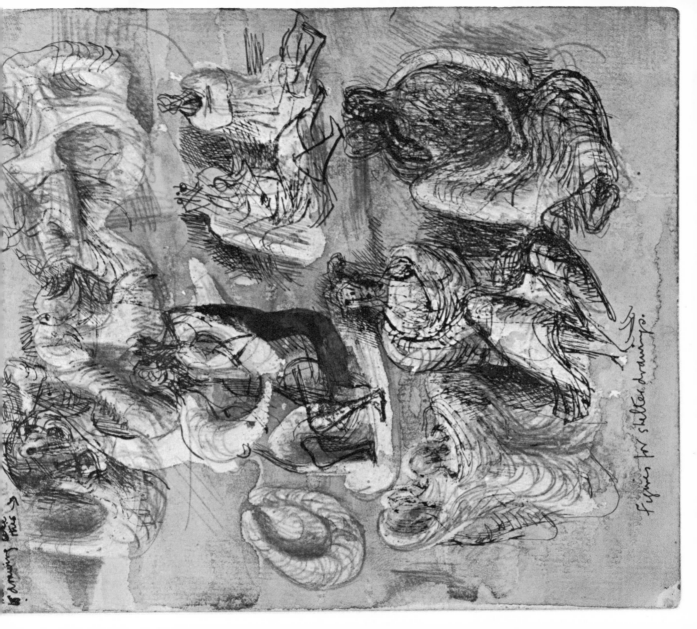

Figures for shelter drawings.

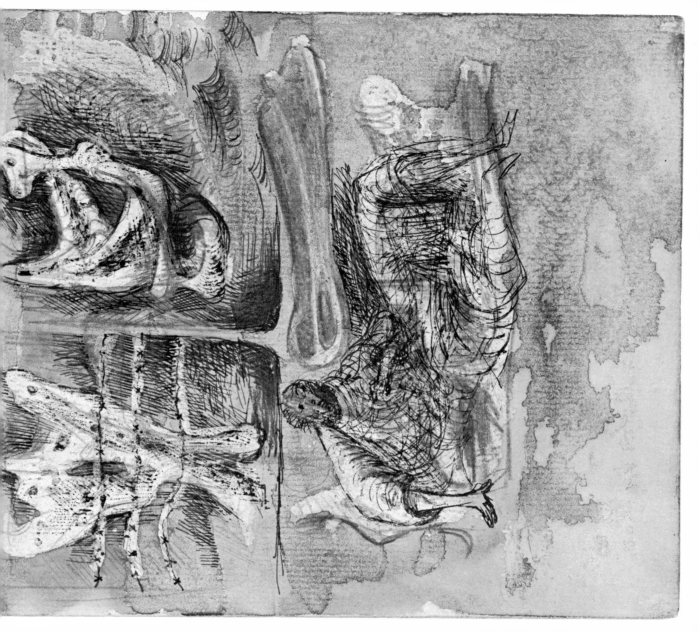

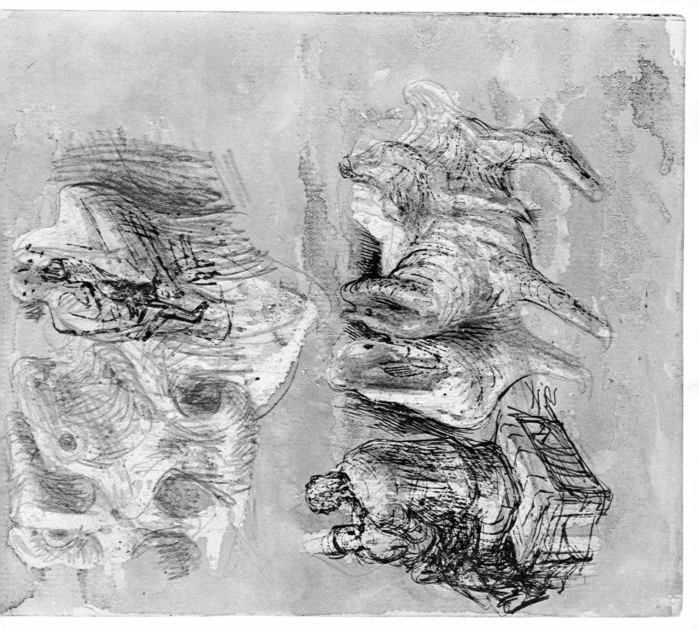

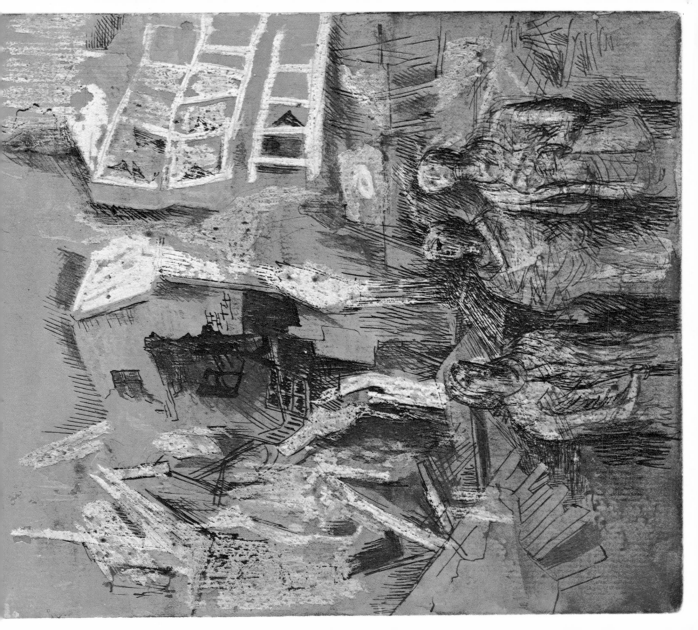

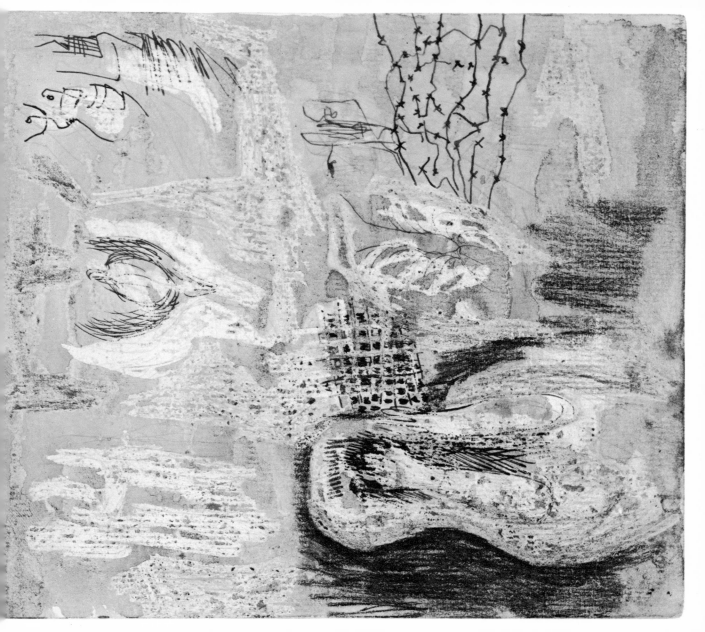

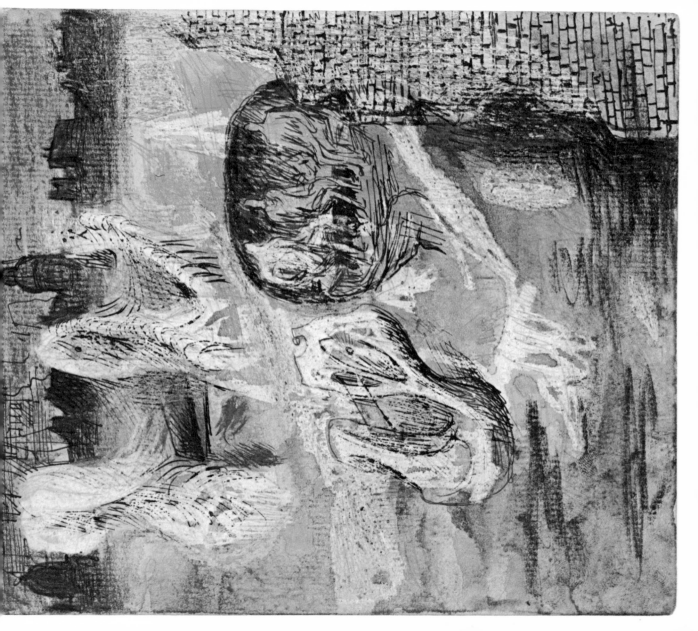

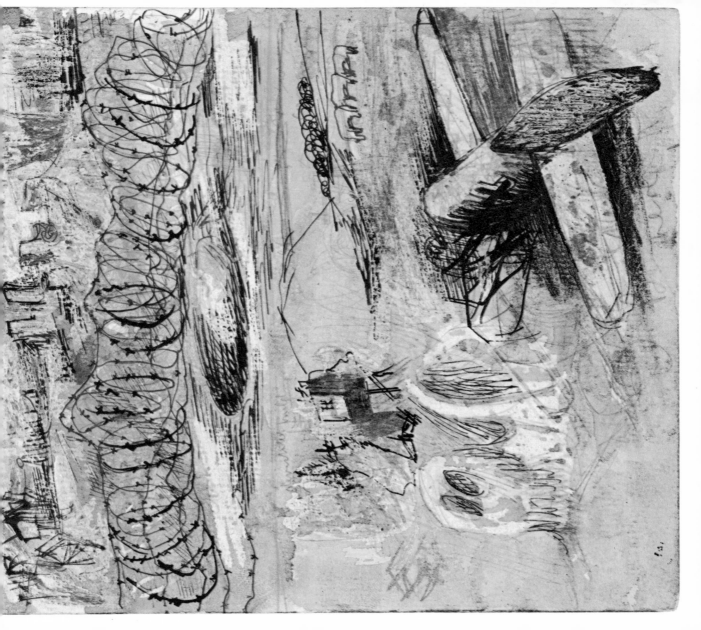

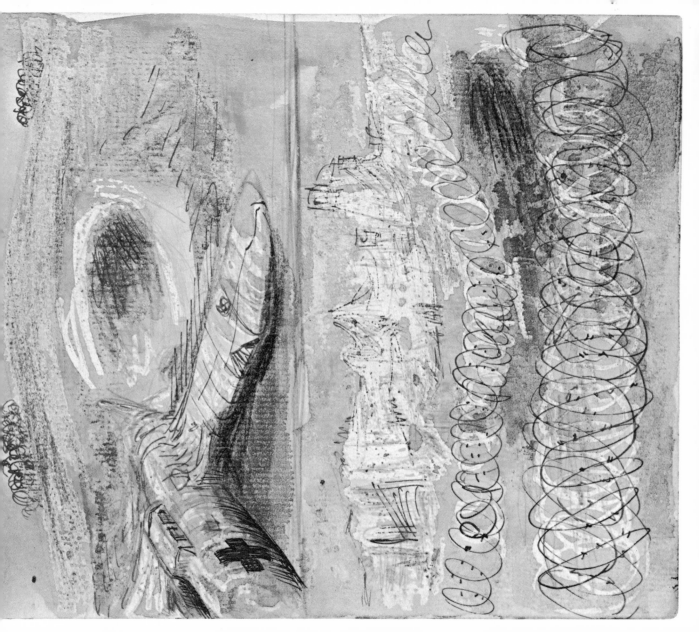

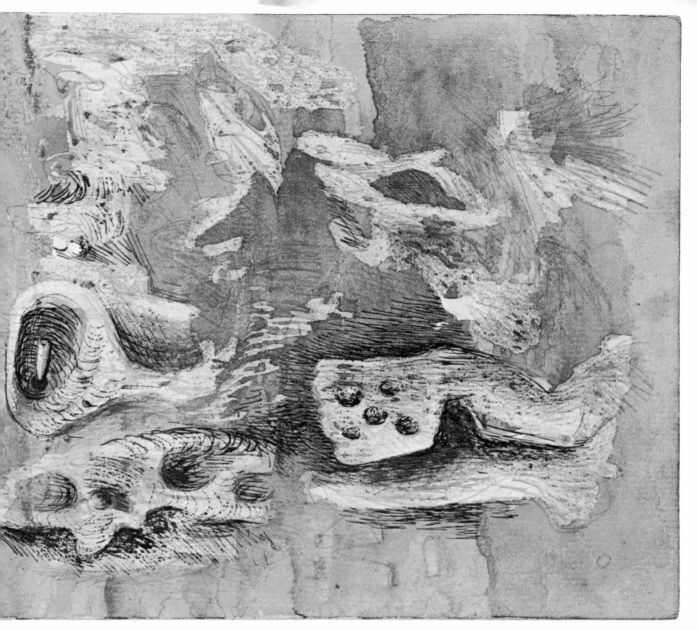

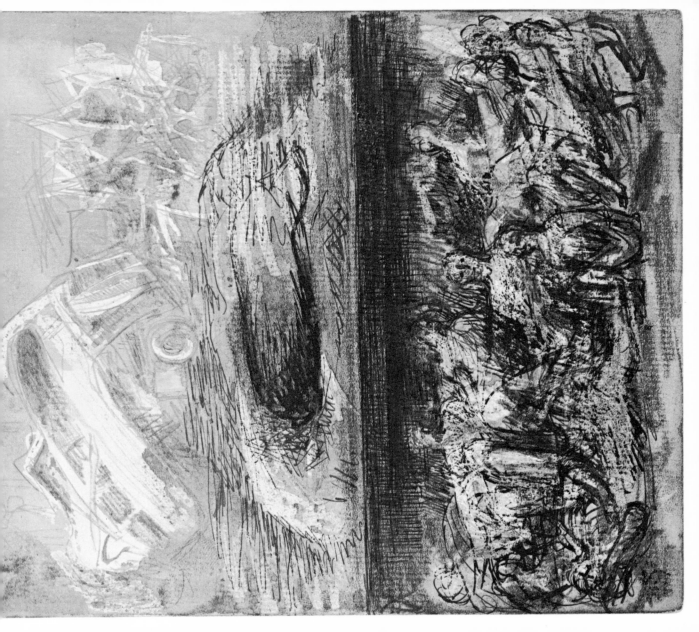

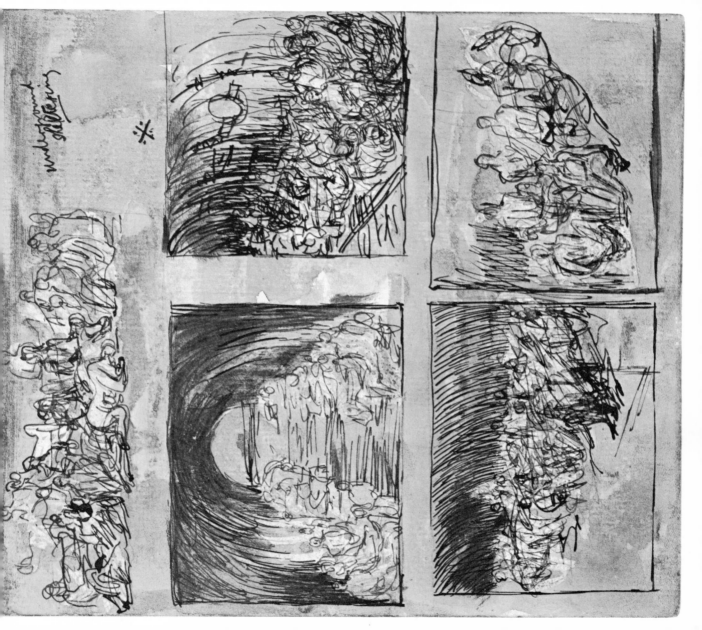

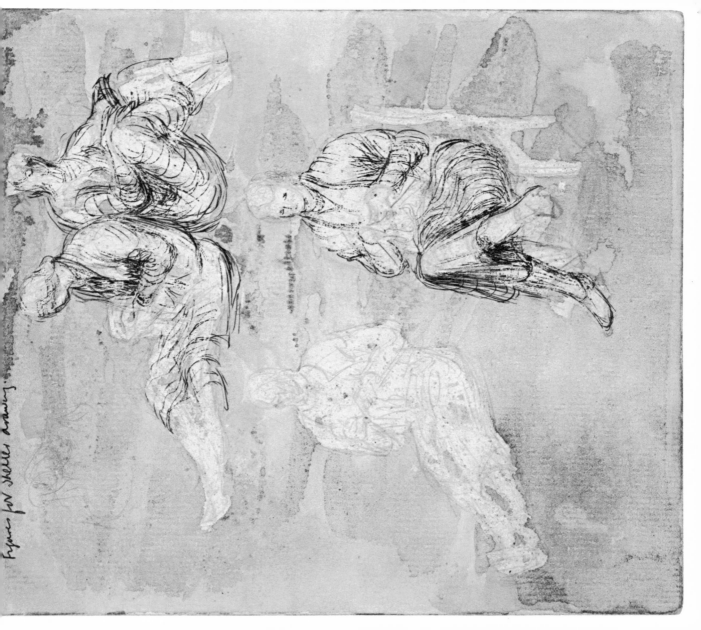

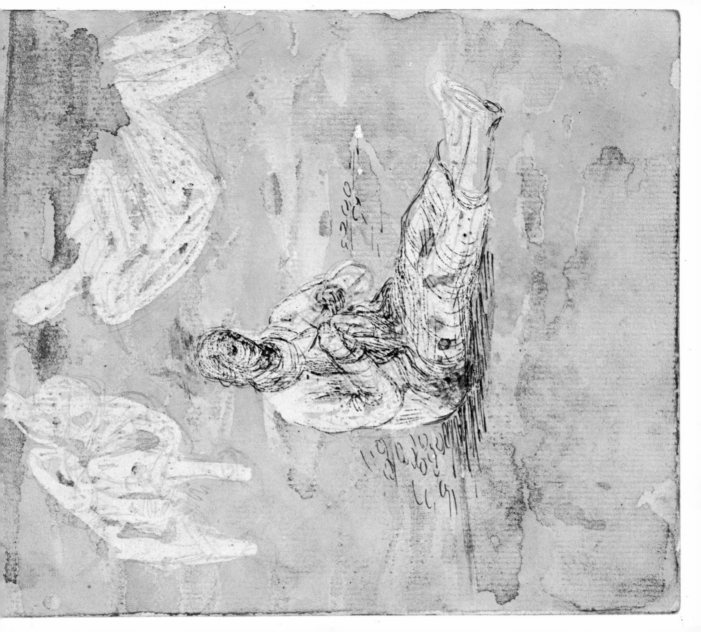

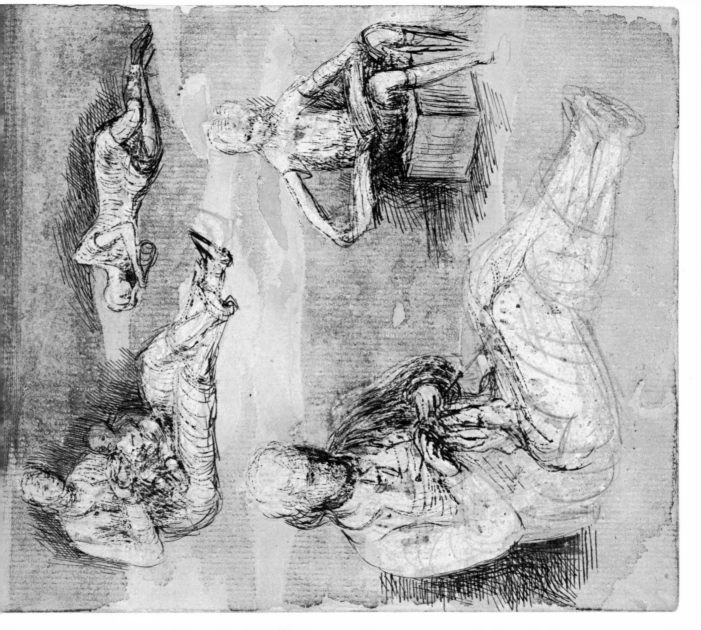

① Three seated figures in front of demolished house

② Grouped figures amongst devastated building.

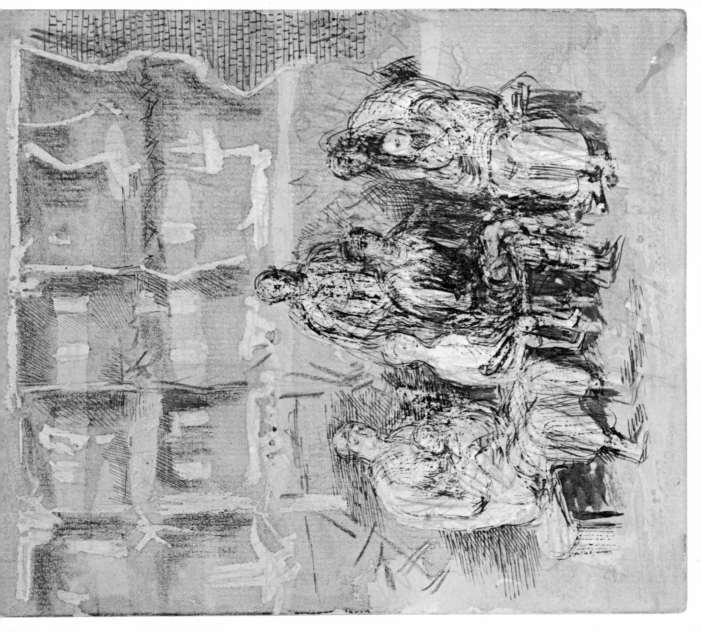

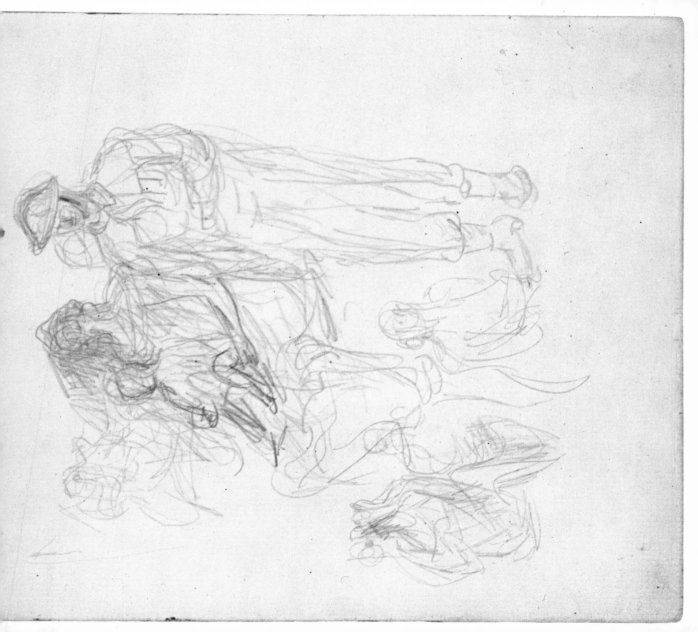

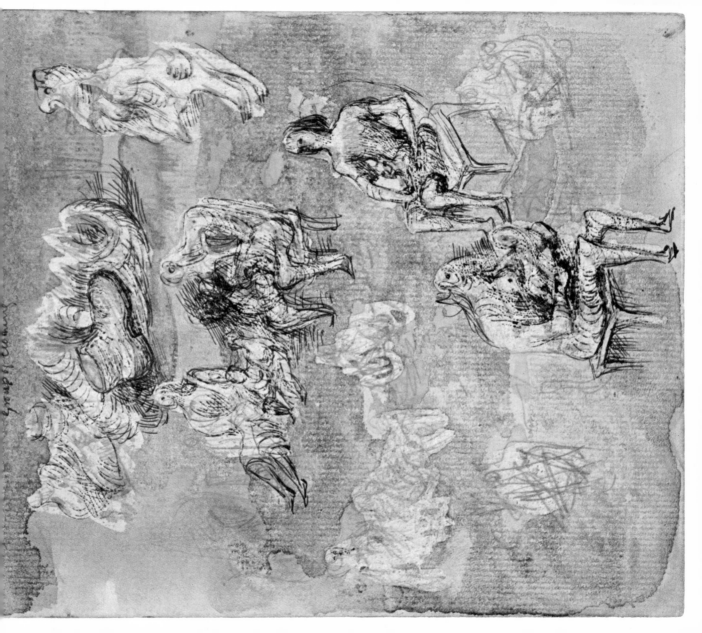

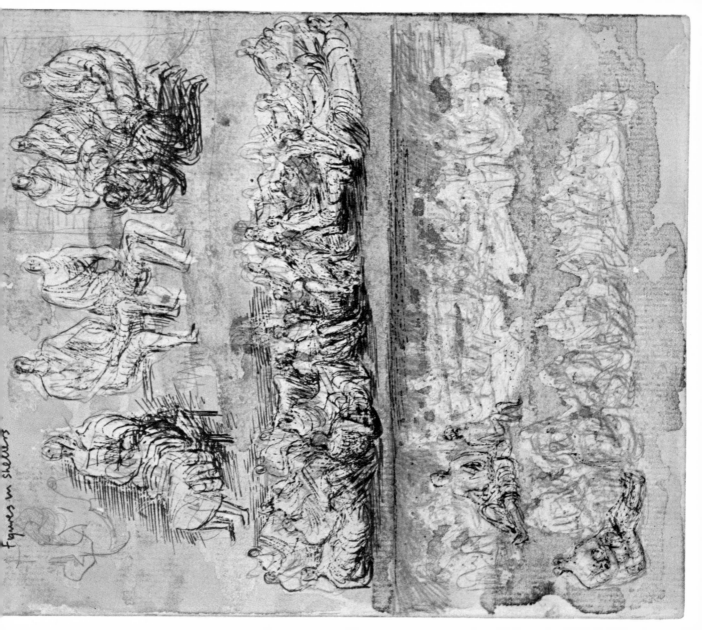

Figures in shelters

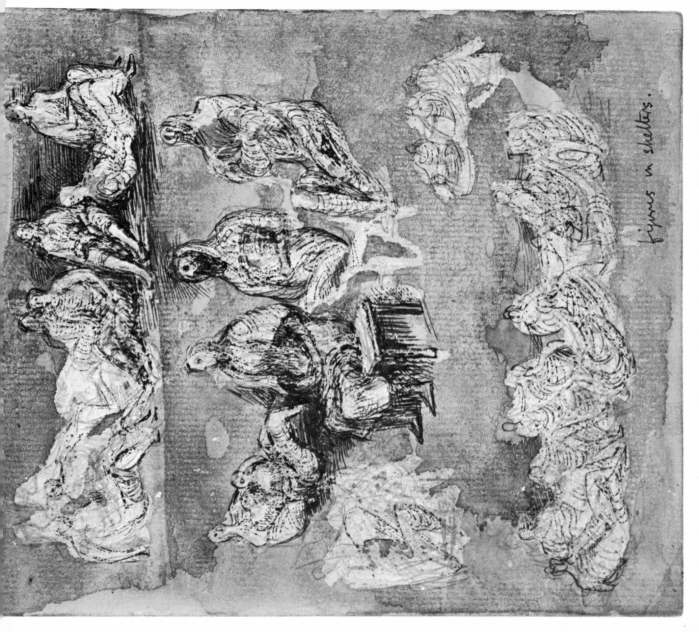

figures in shelters.

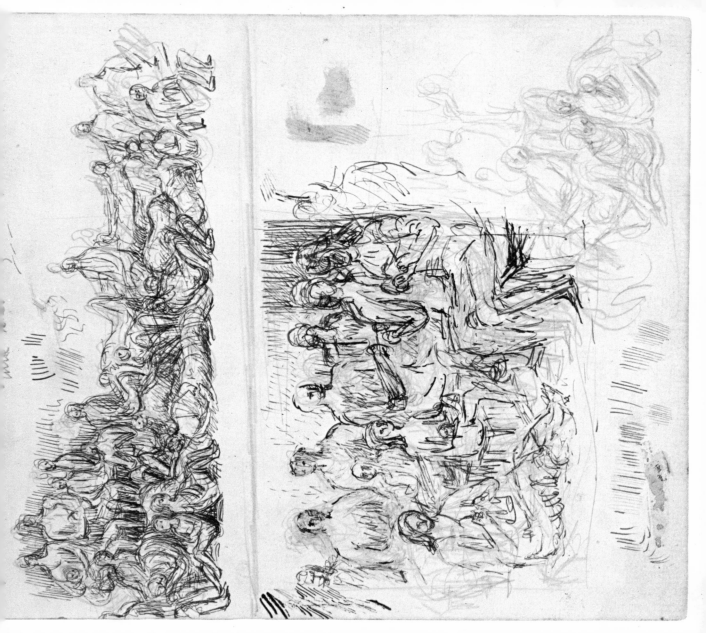

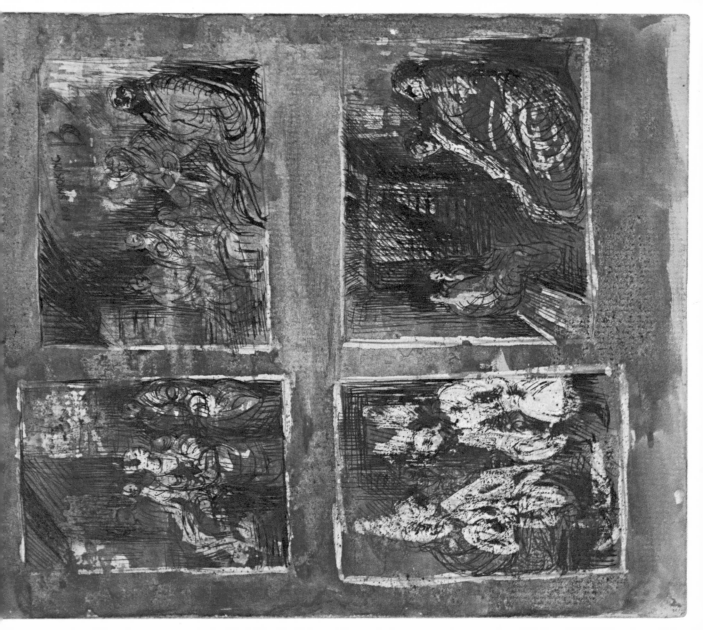

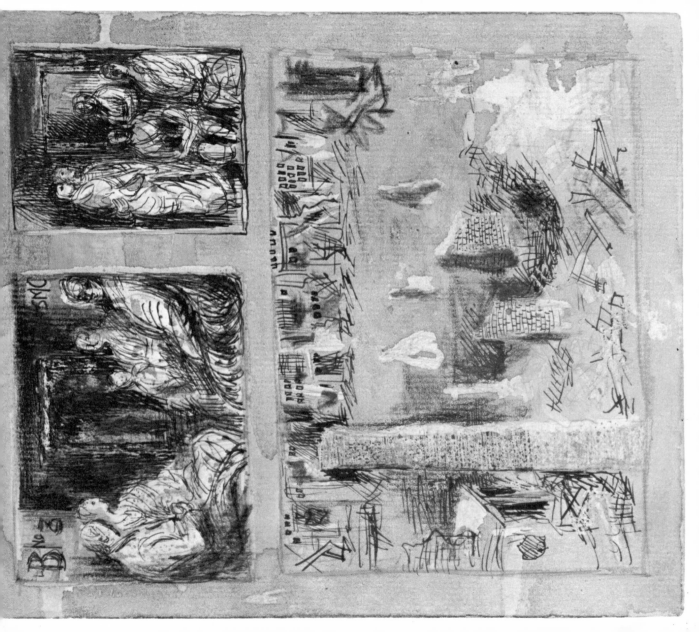

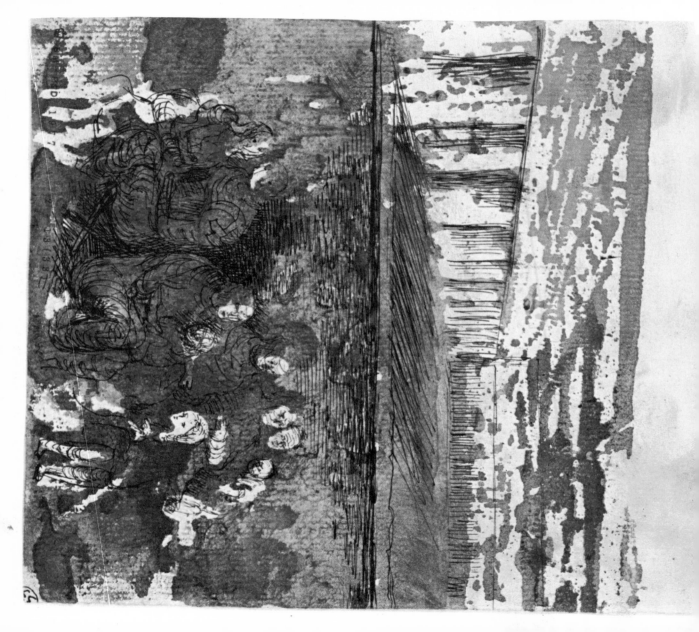

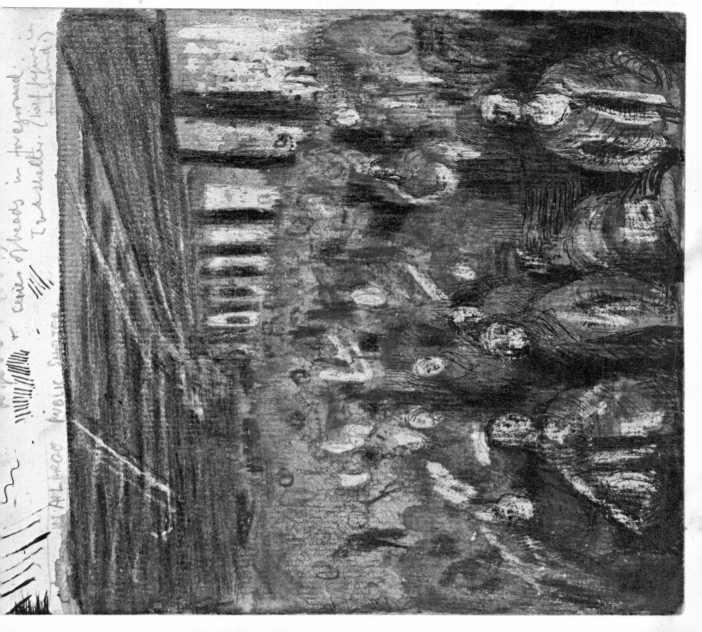

34

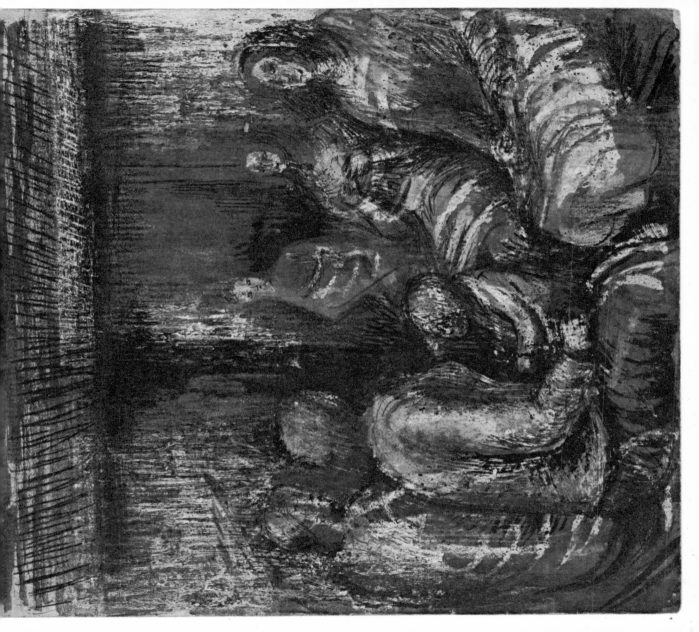

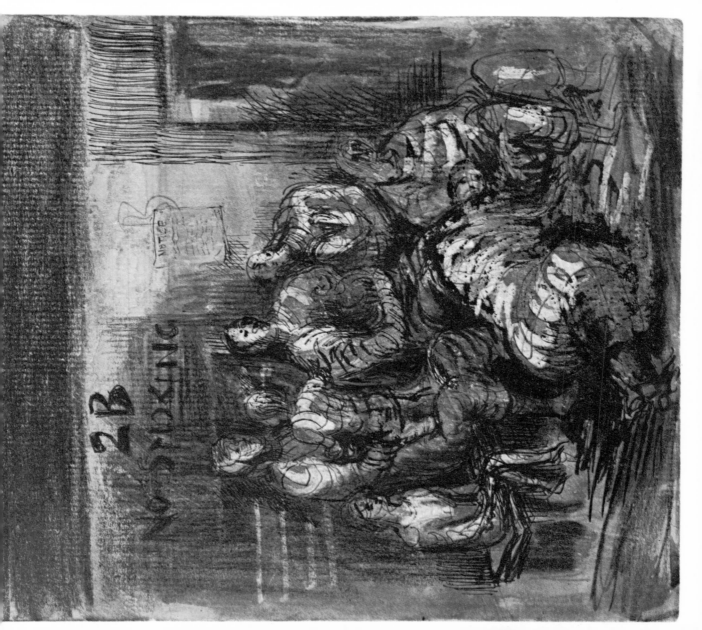

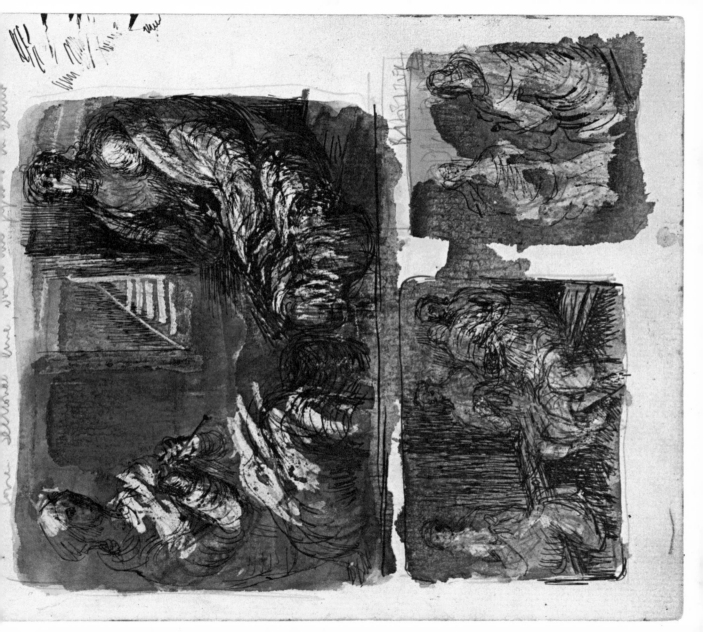

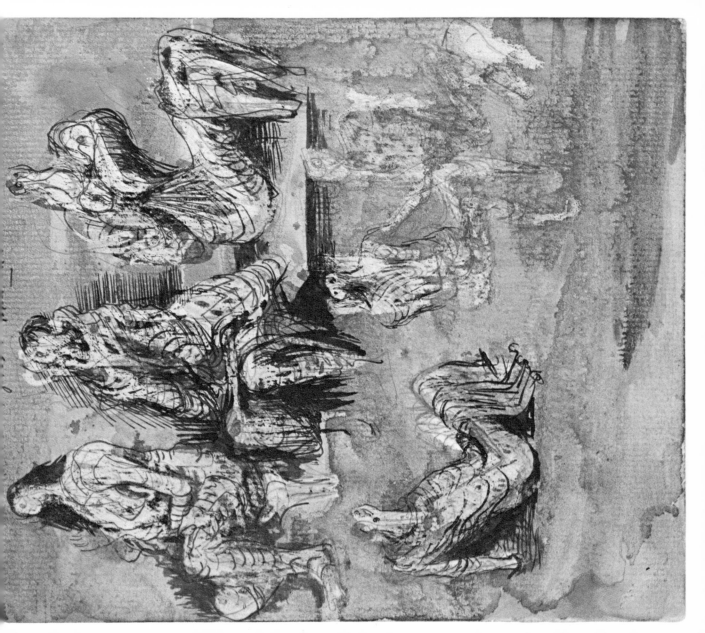

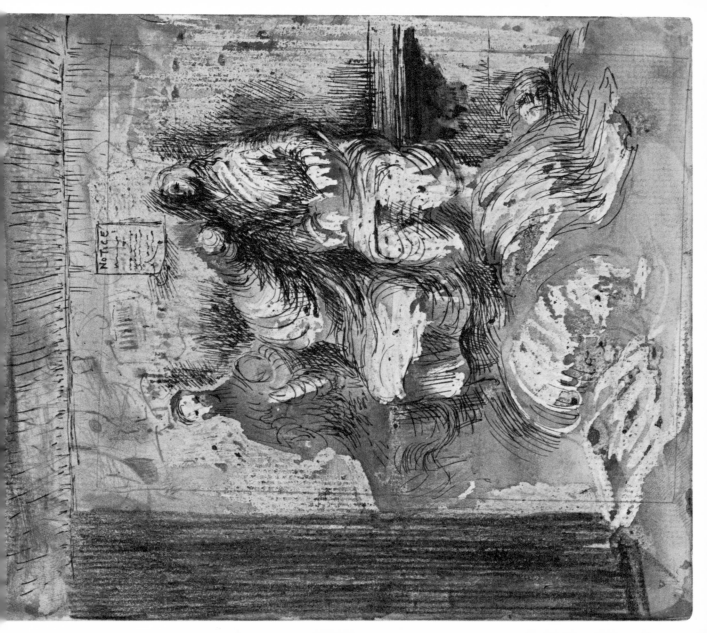

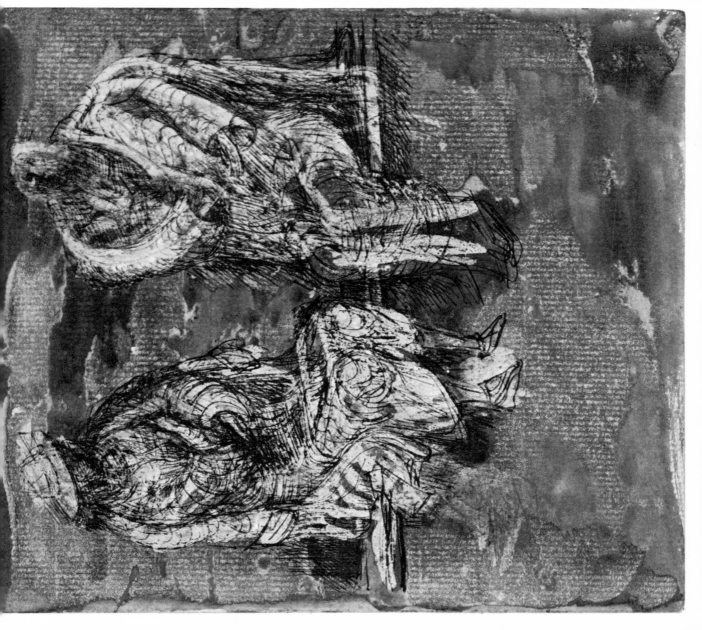

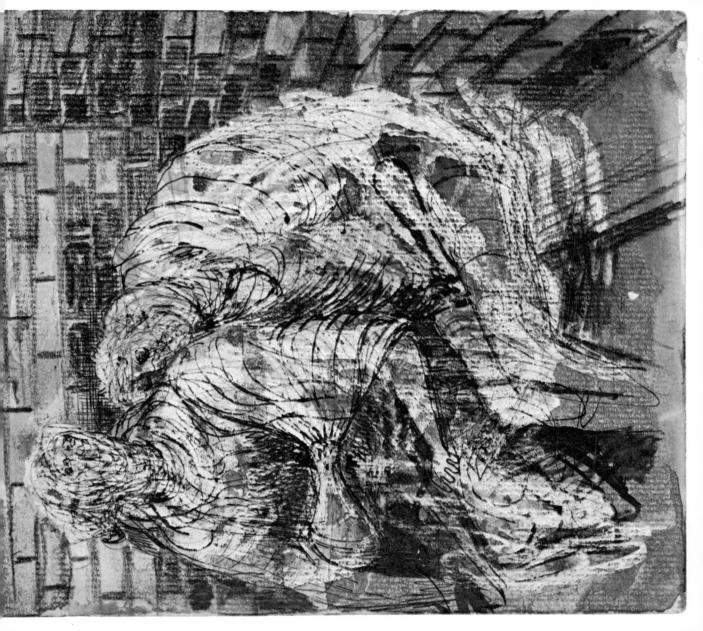

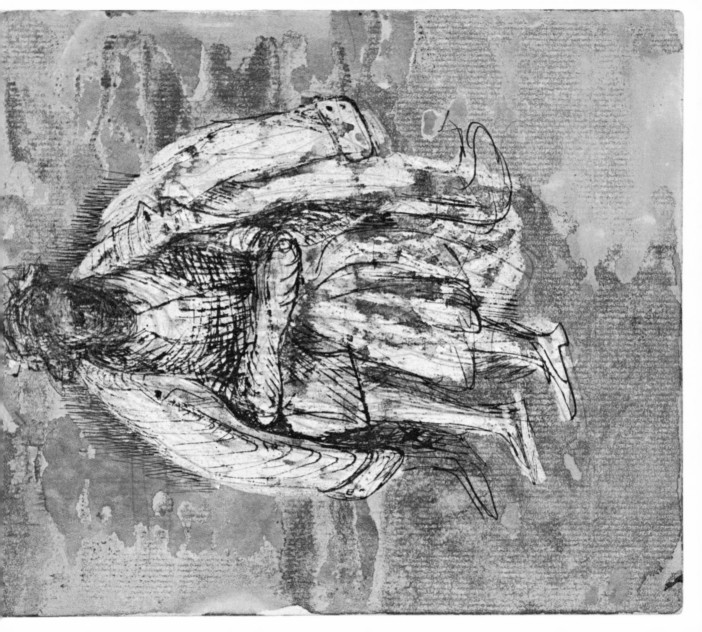

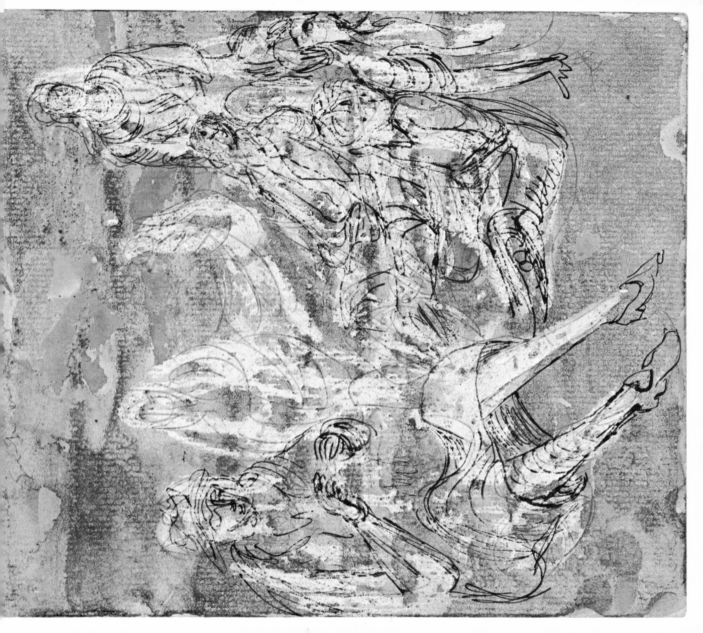

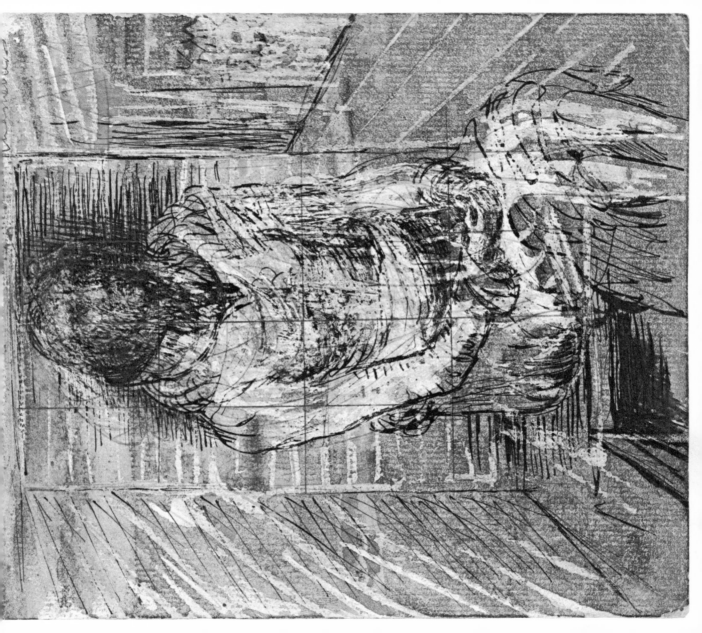

War possible subjects.

Blanketed figure in bombed street.
Sectional line drawings of draped recluin_
Contrast of peaceful normal, and
sudden devastation - (burning cows)
Figure pinned under debris
Night & day contrast.

Abstract figures
with shelter background.
Disintegration - of bomber
figure by machine
Contrast of opposite.
demolished building
+ cows grazing

Single large figure
whole figure against
bomb-splintered wall.

Composite picture of
demolished buildings +
shelters + london skyline

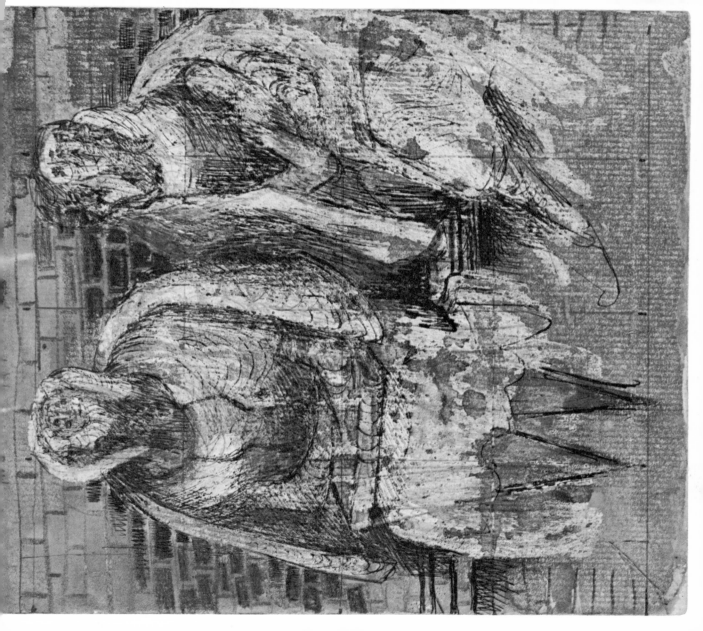

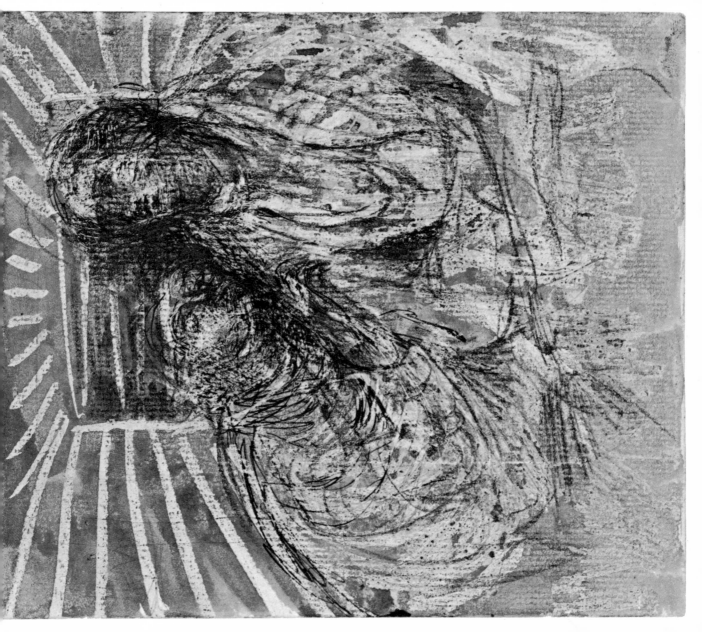

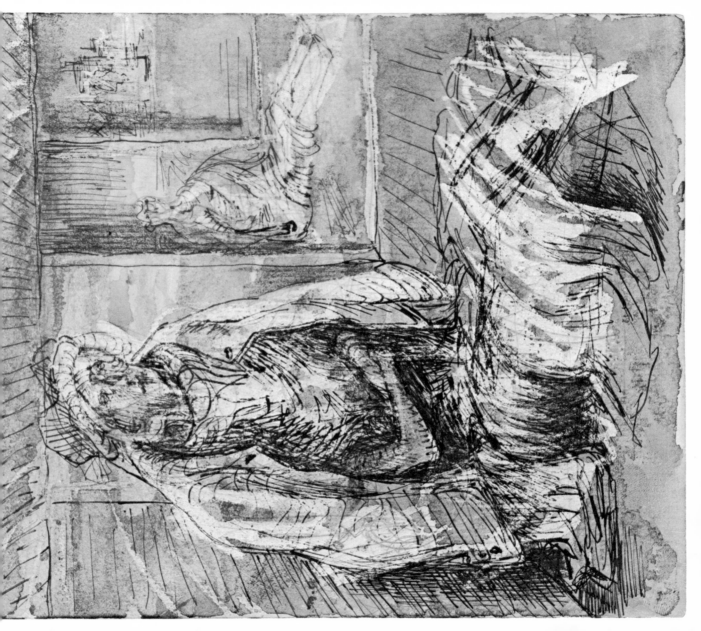

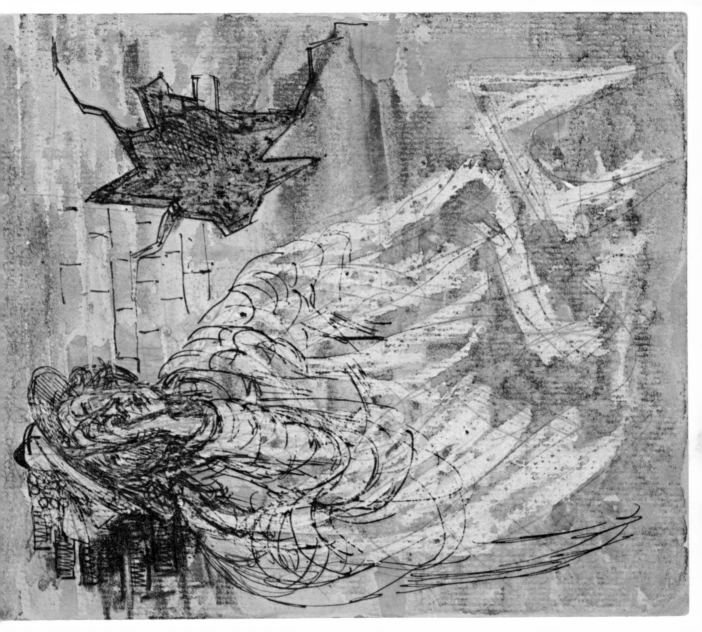

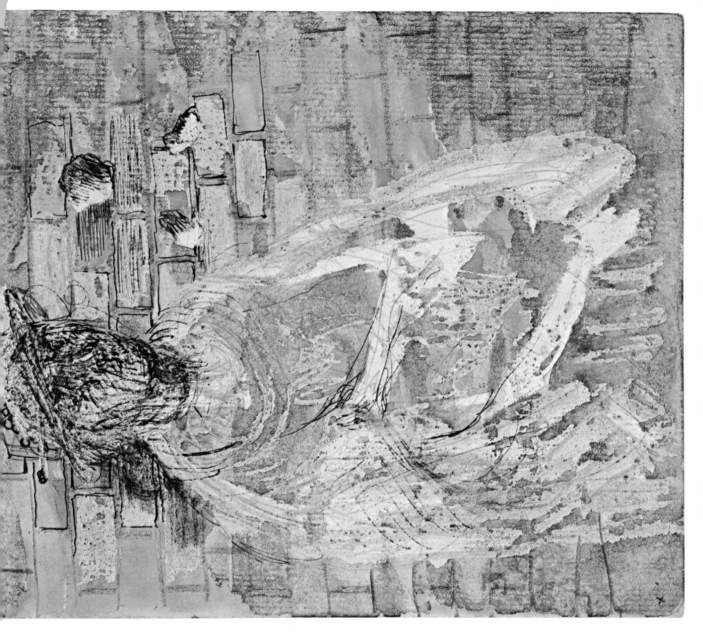

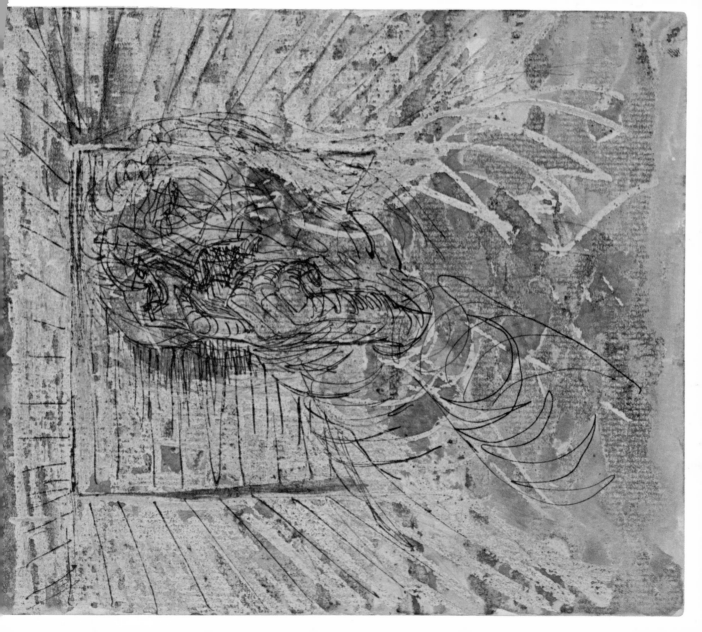

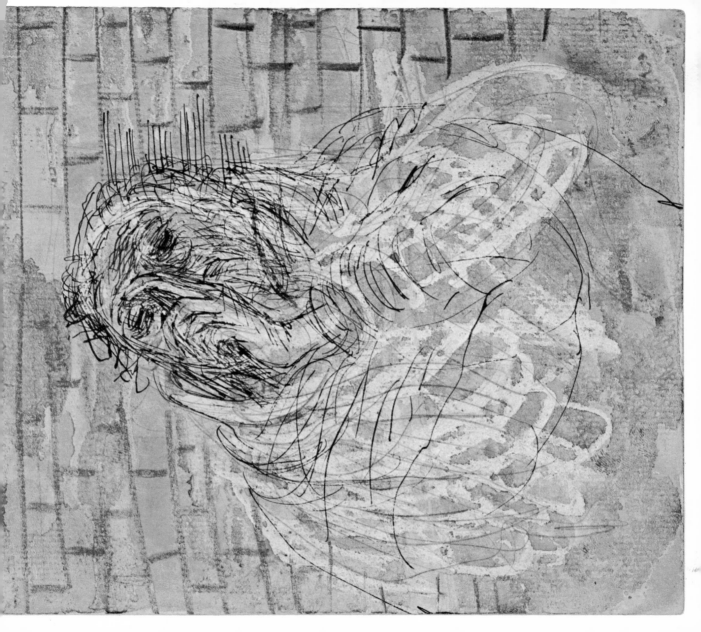

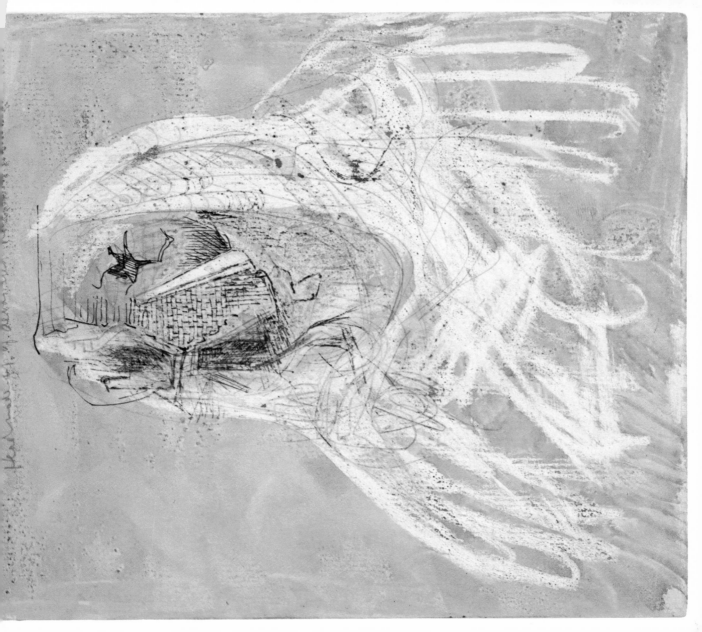

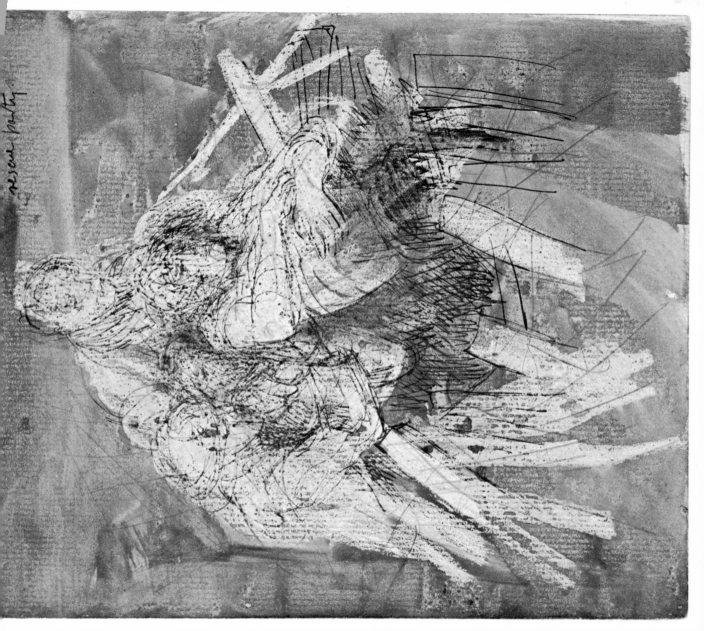

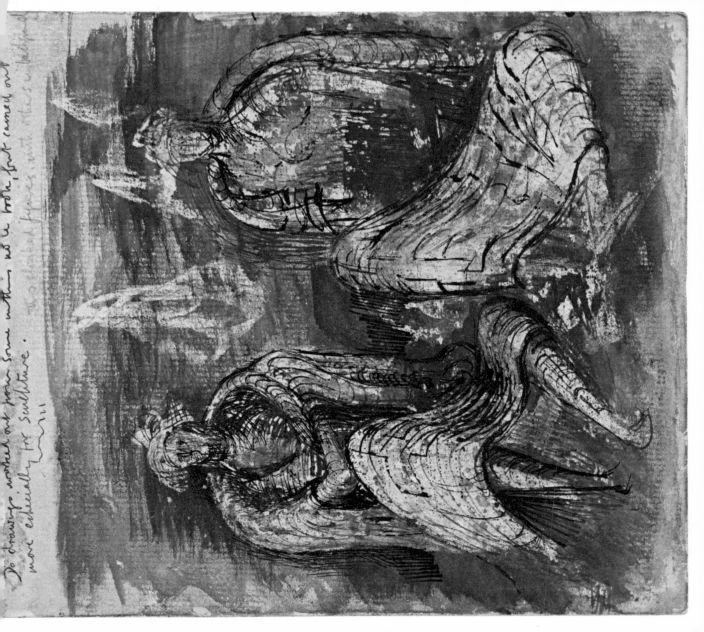

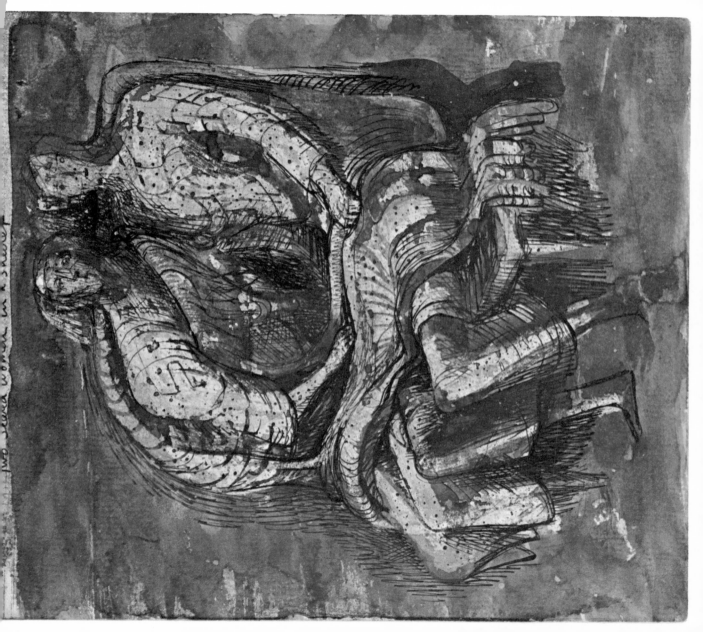

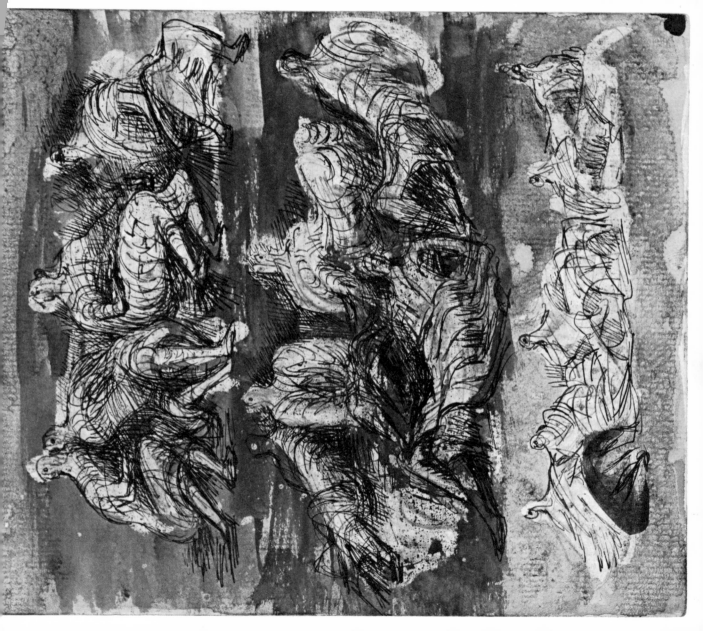

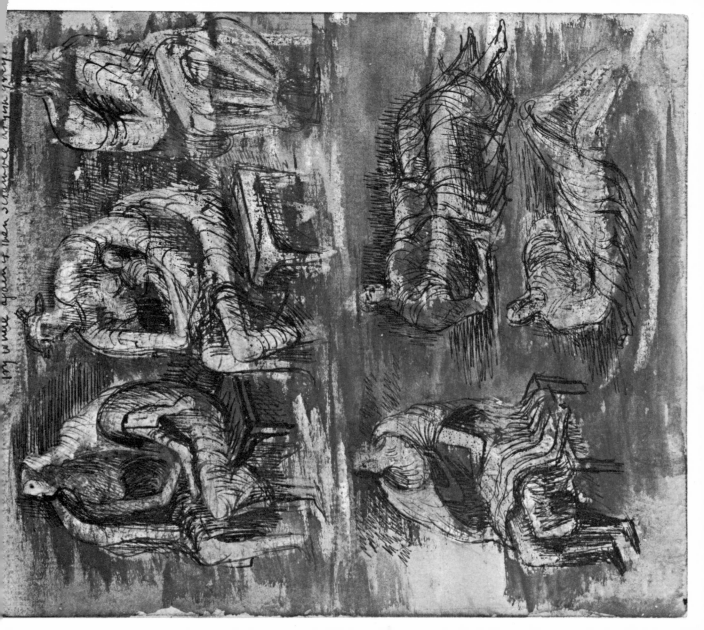

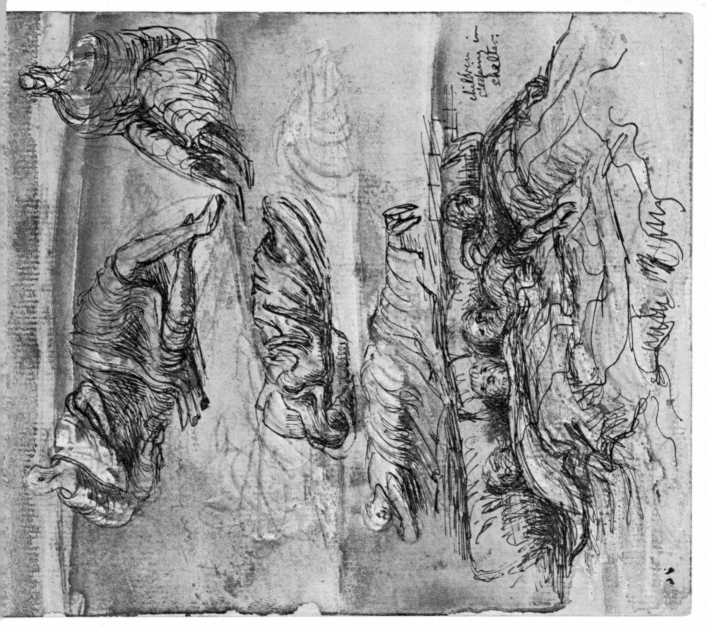

children
sleeping in
shelter;

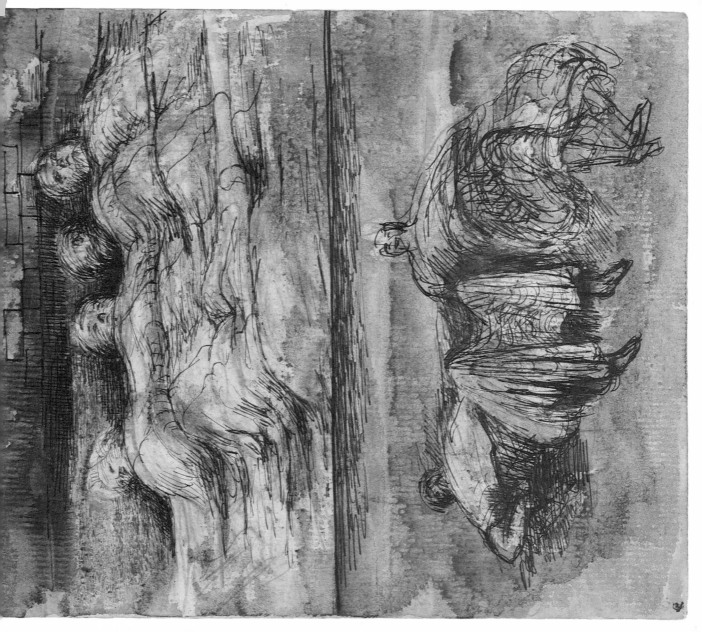

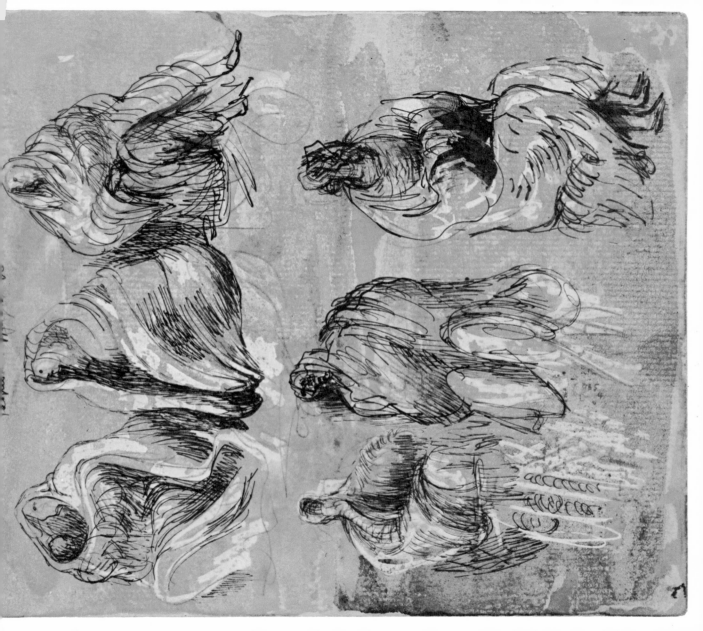

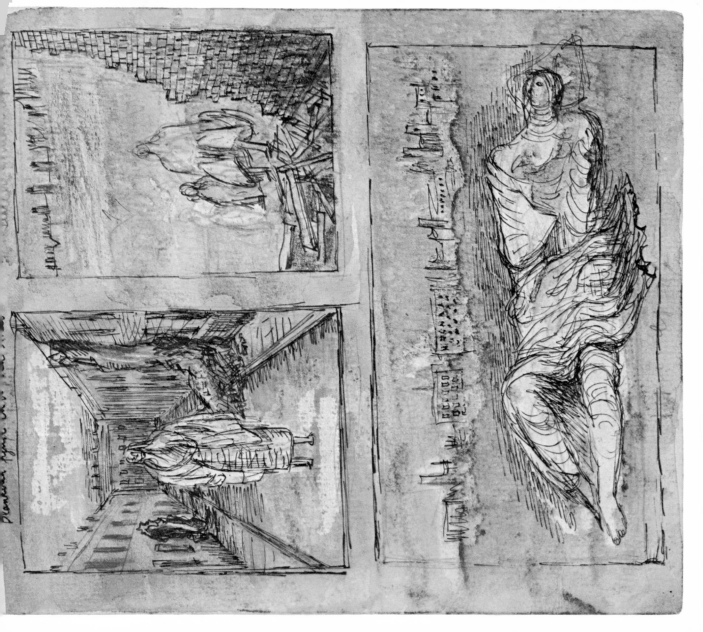

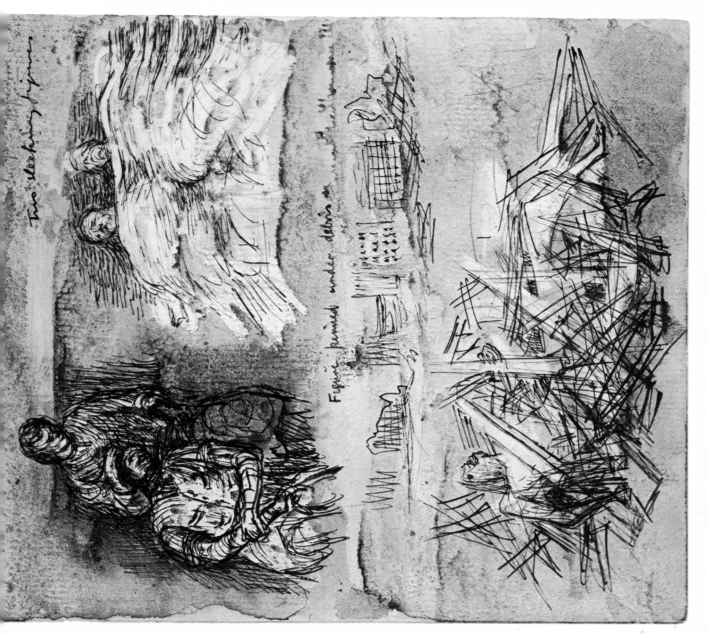

Two sleeping figures

Figure pinned under debris

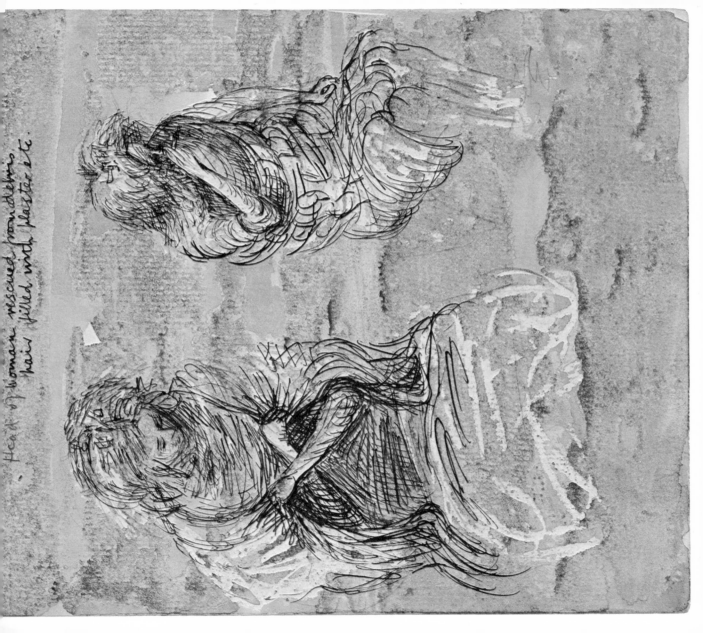

Head of woman rescued from debris, hair filled with plaster etc.

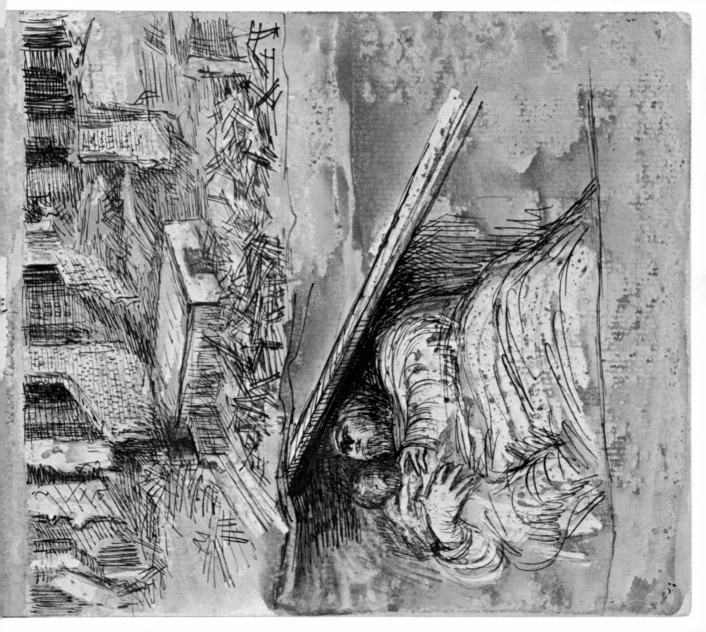

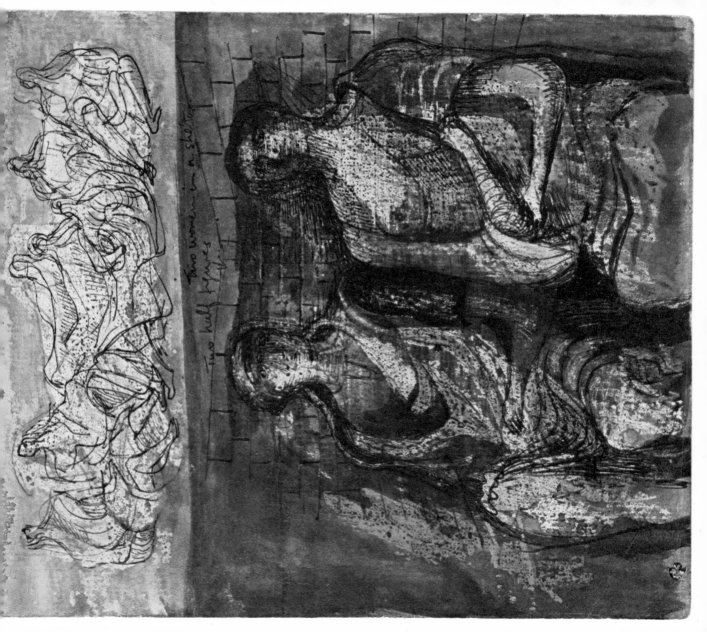

Two women in a Shelter
Two half figures

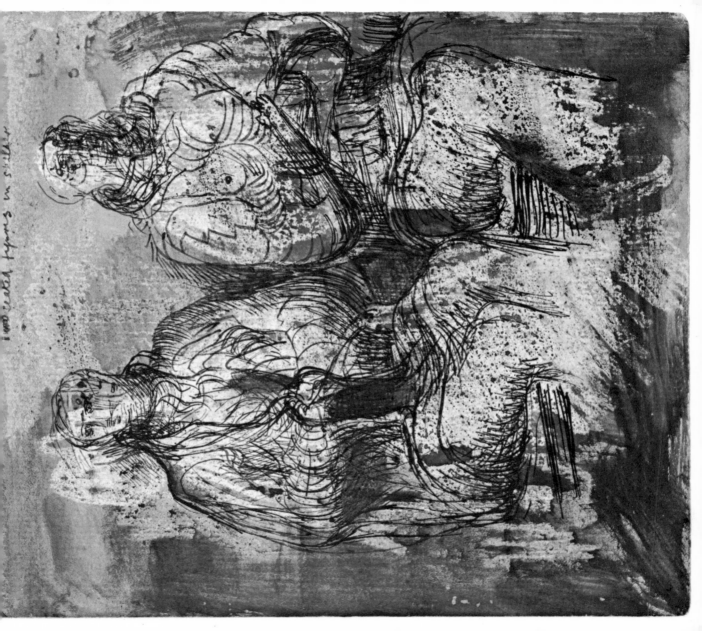